"Edgar Allan Poe's

Petersburg

The Untold Story of
the Raven in the Cockade City"

Jeffrey Abugel

Charleston | London

THE
History
PRESS

Published by The History Press
Charleston, SC 29403
www.historypress.net

Copyright © 2013 by Jeffrey Abugel
All rights reserved

First published 2013

Manufactured in the United States

ISBN 978.1.60949.864.1

Library of Congress CIP data applied for

To Eddy and Sissy, in whose honeymoon suite this book was written.

CONTENTS

INTRODUCTION

It was very likely the happiest time of his life. Yet despite the hundreds of books and articles written about the life of Edgar Allan Poe, few devote little more than a footnote to the honeymoon he enjoyed with his child bride, Virginia Clemm, in Petersburg, Virginia.

Petersburg is one of the most historic cities in the Southeast. But most of its publicized history relates to the Civil War, the Battle of the Crater and the Siege of Petersburg. In decades before the war, however, the town was a rich center of trade, ideas and entertainment, with a diverse culture that included people of French, Haitian and Scotch-Irish descent, as well as the largest free black population in the South.

Much of the history of this city, just twenty miles south of Richmond, has been buried in obscurity for decades, just as Poe's early manhood—with his clean-shaven face, natural athleticism and ability to live by his wits—has taken a backseat to the dark, mustachioed literary figure more familiar to the world.

This book is built around two things that have been largely ignored by Poe fans and scholars—his relationship with Petersburg, beginning with his mother's many appearances as an actress, and his friendship with fellow poet and newspaper editor Hiram Haines. (Haines' wife actually lived near Poe as a child, and people often mistook them for brother and sister.)

Until recently, Haines was buried not only in Blandford Cemetery but in obscurity as well. Documentation about his life, his work and his relationship with Poe was briefly brought to light in the 1930s and then subsequently

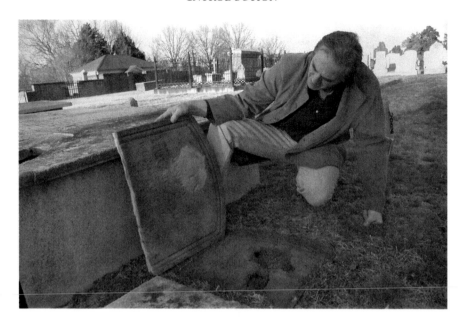

The author discovers the grave of Hiram Haines in Blandford Cemetery. It has now been completely restored. *Photo by Michael Adams.*

forgotten. Locally published histories of Petersburg, which proliferated in the 1950s and '60s, often relied on sketchy facts and oral histories. This book is meant to illuminate the origins of the symbiotic friendship enjoyed between Poe and Haines, while portraying, as accurately as possible, the thriving city that Haines called home and that Poe chose as the ideal romantic escape.

CHAPTER 1

BRINGING BACK THE DEAD

I confess. I was never Edgar Allan Poe's biggest fan. I respected his place among American poets but pretty much left what I'd read behind in high school. Too many Hammer films, too much Vincent Price had long dissociated me from the body of work that went so far beyond "A Cask of Amontillado" and "The Raven." Over time, the words of my favorite authors—Borges, Camus, Miller and Mishima—became sacrosanct. Poe, somehow, seemed more Halloween than hallowed.

When I moved to Petersburg eight years ago, everything changed. Many aspects of Petersburg seem illogical, if not downright surreal. Not the least of these is the fact that the town possesses more fascinating history per square foot than virtually anywhere on the planet—history that is largely unsung and unknown.

With its riverside site and abundant historic architecture, the town's potential seemed boundless. But its chronic inability to tap into that potential can tax one's patience. In time, some folks just pack up and leave—unless they find a reason to stay. For me, it was Poe.

From the outset, locals told me that Poe had spent his honeymoon at what is now 12 West Bank Street. Furthermore, his parents were actors who performed in one of the many theaters in a vibrant, prosperous Petersburg before he was born. So why were there no historic markers, no tours for Poe fans, no proof of all this beyond an oral tradition?

As if compelled by otherworldly forces, Poe's honeymoon quietly became my secret obsession. Where was the proof, I wondered? If the

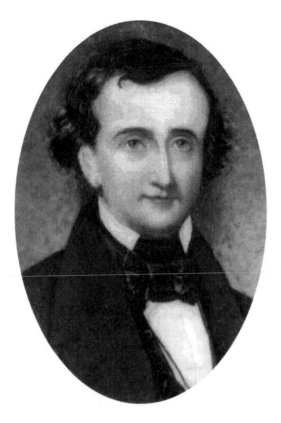

Poe as a young man was well groomed and clean-shaven. He would have appeared much like this growing up in Richmond as an athletic young man known for his feat of swimming the James River against the current.

site was bona fide, I felt perversely compelled to acquire it before someone else did.

I decided to approach the owner, who had quietly done much to revitalize Petersburg through the years. She rarely sold a building, but when she did, it was to someone who cared about history and the town's future. Over lunch, I laid out my plans. The owner knew about the alleged Poe connection and was pleased that I had done some homework. It looked like we might be able to strike a deal when the time was right, and that time might be sooner rather than later.

"Be careful what you wish for," I reminded myself. There was still the matter of actually proving that Poe and Virginia had honeymooned at the building that now seemed within reach.

Months passed, and I was given the opportunity to explore the building. While the street-level retail space had been leased for some time, the upper levels of No. 12 far surpassed my expectations. It had not been inhabited by anyone for many decades. Aside from crude electrical conduits outside the ceilings and primitive bathrooms with claw-foot tubs, the rooms looked just as they did in 1814 when they were constructed. Unlike so many Petersburg buildings, it had never been pillaged; the heart pine floors were remarkably intact, protected in part by piecemeal remnants of art deco linoleum. At the ceilings, hand-carved dentil moldings were in place and untouched. Of the six fireplace mantels, one with an early shell motif stood proudly against a wall like a relic of Monticello. Remarkably, much of the soft green peeling

paint in every room was in fact original. Horsehairs within the ancient plaster confirmed the period of construction. This faded elegance seemed almost habitable but for the layers of dust and pigeon droppings accumulated through the ages.

In addition, an oversized second-level door opened to a curious walkway, which, crossing a silent and dark chasm below, led to a second building few people even knew about. There was a complete rear structure that served as a bakery at some point. The ovens had collapsed into rubble, and a roof now covered the space between the two structures. A little light revealed the dark chasm to be a magical enclosed courtyard between the two brick buildings.

DIGGING FOR TRUTH

Whether I could afford the building—and a six-figure restoration—was one issue. Whether it was as historic as suggested was another. I had to know the truth, either way.

The scant historical facts about Poe's honeymoon provided the point of departure. Poe married his thirteen-year-old cousin, Virginia Clemm, when he learned that her mother (Poe's aunt Maria) was considering sending her away with a wealthy relative. Marrying her was the way to keep his beloved child companion close.

They wed in Richmond in 1836 and then proceeded to Petersburg for their honeymoon. Most biographies end there, with Poe heading back to work at the *Southern Literary Messenger*. It is, for sure, a touchy subject, even today. Some accounts, in Poe's defense, claim the marriage was not consummated for years. Witnesses recall Poe and Virginia playing leapfrog in Richmond parks, behaving more like young playmates than husband and wife.

Trying to learn much beyond these accounts online led to an informational vacuum. But the Library of Virginia and the Petersburg Courthouse held clues. Handwritten records including little WPA make-work biographies on index cards, Poe's known correspondence, typewritten personal histories and 1930s journals of the College of William and Mary provided tidbits that collectively completed a historical puzzle.

The image revealed was that of Hiram Haines, poet and editor of the local newspaper, a man with whom Poe had corresponded regularly—the man who hosted Edgar and Virginia's honeymoon at his Petersburg tavern.

A Poet's Poet

To me, historic preservation means more than shoring up old buildings. It means remembering the people who inhabited those buildings, the lives they led, the things they thought. Poe's friend Hiram Haines was indeed a man worth remembering. His Coffee House or "restorative," a place for food, drink and lodging, hosted not only Poe but also intellectuals, poets, journalists and politicians at a time when the country was still young, still defining its place in the world at large, politically and artistically.

As a teenager, Haines wrote and read aloud a poem written for the Marquis de Lafayette during the Frenchman's 1824 visit to Petersburg. Later, Haines self-published a book of poems, one of the first to draw attention to the state of Virginia's natural beauty. In time he became editor of the *American Constellation* while Poe was editing the *Messenger* in Richmond. It was during this time that the friendship developed. A mutual love of poetry and the need to promote each other's publications brought them together on several occasions and prompted regular correspondence. (In one letter, Haines offers Poe and Virginia the gift of a fawn, which the couple declined.) Both men died at about age forty. One of Haines' four children went on to edit the *Baltimore Sun*. Virginia Clemm died at age twenty-five, two years before Poe, and is largely considered the inspiration behind Poe's famous poem "Annabelle Lee."

If confirmed, the building in question needed more than a plaque, I realized, more than a paragraph in a guidebook. The place that existed in 1836 needed to return to present-day Petersburg. Hiram Haines' Coffee House, a poet's tavern, demanded more than remembering. It required resurrection.

What Dreams May Come

As my body of collected evidence grew, so did my enthusiasm. Still, some locals claimed that the honeymoon site was destroyed long ago. Some reference materials pointed to "East," not West, Bank Street. Yet others claimed that the couple stayed at Haines' home, not his Coffee House. Then, in an off-limits room in the Petersburg Courthouse, a kind of Holy of Holies place for the older, more fragile documents, I found the answer I sought.

In the old deed books, written records and little hand-drawn diagrams showed the place clearly on Bank Street, off Sycamore where the adjacent

This 1836 ink sketch by William Robertson shows the density of parts of Old Towne during the year of Poe's visit. The white house in the distance was known as Spring Hill, which was built in the 1700s and then demolished later in the 1800s to expand Tabb Street farther west. *Courtesy of Petersburg Museums.*

buildings all still exist in a row. Clear as day, the words "Haines Coffee House" appeared on building number 3, and to my surprise and delight, Haines' "manse" or house was right next door. There was no East Bank Street in 1836, though today the buildings are 12 and 16 West Bank. I later observed that the buildings were interconnected on all levels through doorways that were filled in. So those who said he stayed at Haines' house or his Coffee House were both correct.

The couple spent close to two weeks in Petersburg, according to several accounts. While other small-edition books further confirm the Coffee House as the place they returned to each evening, the fact that Haines lived with a wife, a mother-in-law, four children ages one to eight and probably a few barnyard animals left the Coffee House rooms, designed for visitors, the only logical option, even without further proof.

I retained this secret knowledge for many months, as I fell into the habit of staring at the building from a distance nearly every day. I imagined carriages pulling up to the Coffee House on muddy streets of the 1830s. I envisioned curtains blowing in the open windows and the look of the original lower-level façade, hints of which I had seen in early insurance drawings. I looked

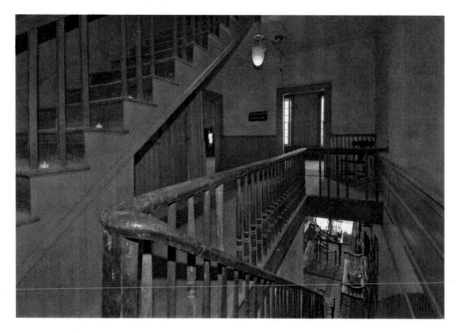

The second-level hallway leads to the honeymoon suite. Upstairs, the landing is much larger to make room for transients or boarders who would have been most likely to stay for only a night or two. *Photo by Jeffrey Kyle Rayner.*

up at the windows and imagined Edgar and Virginia looking out onto the street on a moonlit night.

I thought of the other "poets' taverns" in the world: the White Horse Tavern in Greenwich Village, where Dylan Thomas had taken his last drink and I had taken my first; Les Deux Magot, where Oscar Wilde sipped absinthe and Sartre explored existential nausea; and Harry's Bar, of Hemingway lore. And as I sat and pined over a building, the dream of a literary tavern, a revival of Hiram Haines' original Coffee House, his restorative, somehow began to restore my very soul.

I fed this desire by studying Poe. Having slighted him early in life, I committed myself to reading everything he had ever written and most of his existing biographies as well. I soon realized how much I had missed all these years, not only from a cultural literacy standpoint but from a personal one as well.

Poe suffered things that could not be put into words. His characters often reflected a sense of unreality and anxiety that I myself had explored in the book I coauthored with a psychiatrist in 2004, *Feeling Unreal: Depersonalization Disorder and the Loss of the Self*. Poe, almost certainly, experienced fleeting

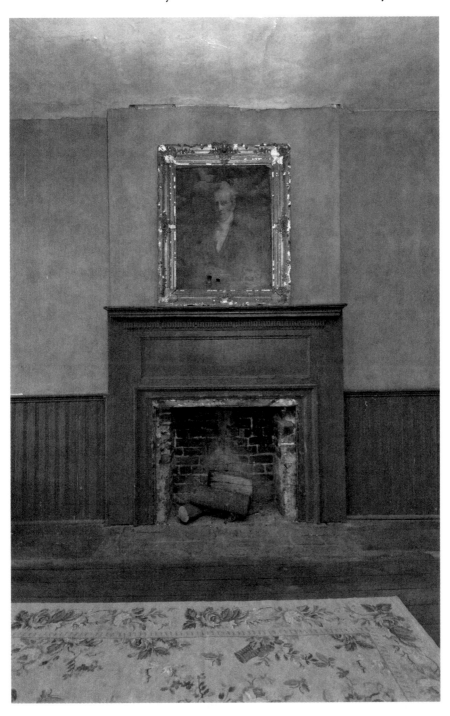

The second-floor bedroom where Poe and Virginia would have stayed for their honeymoon.

Hiram Haines Coffee and Ale House as it looks resurrected today. The rooms upstairs are virtually untouched since the time Poe and Virginia visited them. Legend says that on the anniversary of Virginia Clemm's death, she can be seen looking out the window on the far right. *Photo by Jeffrey Kyle Rayner.*

if not chronic depersonalization—a relentless sense of detachment and dissociation from reality that is often misdiagnosed as depression. Many gifted people use writing to express this condition, as a way of creating *some* kind of reality. Often, self-medication with alcohol or drugs offers a temporary sense of ego, of self, while ultimately worsening the situation overall. Reading Poe completely, in light of the psychological material I had studied for so long, helped me connect with him on a level that would not have been possible otherwise.

In 2010, when I resurrected Hiram Haines' establishment as Hiram Haines Coffee and Ale House, I was confident that Hiram and his friend Edgar would feel right at home. This is the untold story of their friendship and the people and places of the town they came to know well.

Chapter 2

A Thriving Antebellum Town

It lies on the banks of the Appomattox River, roughly twenty miles south of Richmond where Interstate Highways 85 and 95 intersect. Established as a trading post in the seventeenth century, Petersburg, by the 1830s, was a thriving river town, a crazy quilt of cultures with more theaters, racetracks, taverns and boardinghouses than any town of comparable size. In time it grew to become the state's fifth-largest city and a major center for tobacco, ironwork, flour, furniture, publishing and new ideas.

Today, many of its historic structures remain, including more antebellum houses, restored or in disrepair, than any other city in the region. Despite pockets of intense capital investment by individuals, as well as corporate groups seeking valuable tax credits, Petersburg's historic Old Towne remains a historic venue that has yet to be discovered by the world at large. The city overall, which includes five historic districts, has suffered years of financial and sociological problems. But it wasn't always like this. Through most of the nineteenth century and half of the twentieth, Petersburg was a thriving river town and a hub of artistic, political and social activity for the region. And it is due for a comeback.

Few places on earth enjoy the potential, the architecture and the burgeoning sense of rebirth that Petersburg is beginning to celebrate. Most cities offer only sporadic glimpses of their history; Petersburg's streets place you right back into it, block after block. Many of the homes and business structures that Edgar Allan Poe and Virginia Clemm passed as they strolled

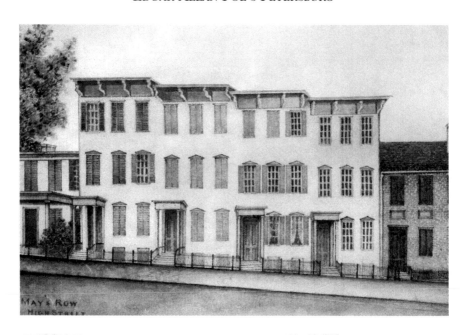

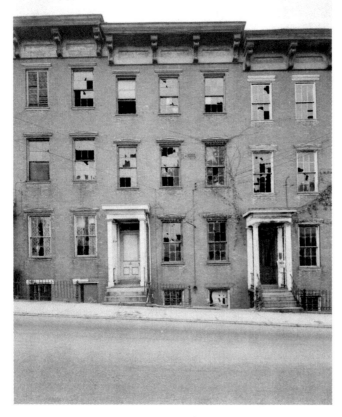

Above: May's Row on High Street was built by attorney David May in 1860. Well-known local artist William S. Simpson, who lived at No. 17, painted this picture.

Left: By the mid-1900s, May's Row, like much of Petersburg, was suffering from neglect and abuse. Thankfully, today these same buildings have been restored to their former glory.

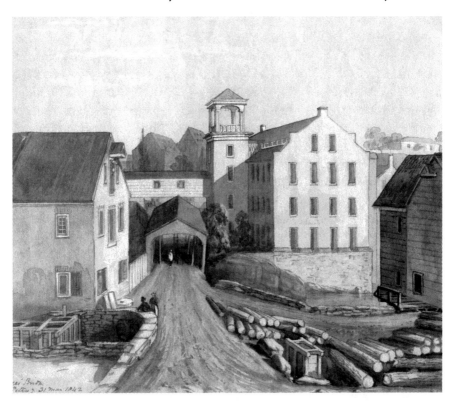

Lumber mills, flour mills, tobacco warehouses and riverside shipyards all proliferated in antebellum Petersburg, especially near the river. Walkways connecting different buildings were also a common sight. *Courtesy of Petersburg Museums.*

through town in May 1836 still remain, much as they were. Unlike most places Poe lived, he would surely recognize Petersburg.

Like many of the earliest American settlements that grew into towns, Petersburg was born on the banks of a river, in this case the Appomattox, providing a natural trade route leading into the James River and the open seas beyond. Native Americans, under the domain of the ruler Powhatan, first tapped into the region's natural resources. Increased population in the seventeenth century brought the establishment of parishes, trading posts and eventually forts. In time, trading with the Native Americans as a livelihood became secondary to the cultivation of tobacco.

Peter Jones' trading post, circa 1670—the ruins of which are a tourist attraction in Old Towne Petersburg—marks what many historians consider to be the origin of the name "Petersburg." As counties were carved out, what was to become Petersburg was known as Bristol Parish, established in 1643.

Its pivotal structure, Blandford Church (1735–37), not only survives today but also serves as one of Petersburg's major tourist attractions. Located in the sprawling and historic Blandford Cemetery, the church is one of only a few adorned completely with stained-glass windows created by L.C. Tiffany himself. Each window, installed at the turn of the nineteenth century, represents one of the Confederate states through stunning depictions of biblical saints.

In 1748, the towns of Petersburg and Blandford were incorporated.

By the mid-eighteenth century, the architectural bar was set high through the construction of Battersea, the earliest surviving example of a five-part Robert Morris–style Palladian house form in the United States. Built by John Bannister, the first mayor of Petersburg, and currently preserved by the Battersea Foundation, the structure was one of many large estates that proliferated at the time and still exist, often in private hands. It is suggested that Thomas Jefferson may well have assisted in its design.

MILITARY MIGHT

As Petersburg grew in size and stature, it played a role in the Revolutionary War as well. The British occupied it twice, but the 1781 Battle of Petersburg proved that the Virginia militia could take on hopeless odds and engage the best army in the world. As in most other towns, some Tories and Scottish merchants liked things as they had been, doing successful business with the Brits. But the majority of citizens were Patriots on the side of independence, despite the hardships such a stance promised to bring.

General Henry "Light Horse Harry" Lee, father of Robert E. Lee, explained why there was a Battle of Petersburg and emphasized the town's strategic importance at the time:

> *Petersburg, the great mart of that section of the state which lies south of the Appomattox, and of the northern part of North Carolina, stands upon its banks about twelve miles from City Point; and after the destruction of Norfolk, ranked first among the commercial towns of the state. Its chief export was tobacco, considered our best product, and at this time its warehouses were filled. In addition were some public stores; as this town, being most convenient to the army of Green, had become a place of depot for all imported supplies required for southern operations.*

The Untold Story of the Raven in the Cockade City

In April 1781, British general William Phillips and his army, bent on destroying tobacco reserves, marched on Petersburg. One thousand Virginians, mostly militia, faced more than twice their number. After several hours of fighting, the Americans moved across Pocahontas Bridge and then burned it, stopping the British pursuit. Afterward, Thomas Jefferson praised "this initiation of our militia into the business of war."

General Muhlenburger, in charge of operations locally, noted, "The militia behaved with a spirit and resolution which would have done honor to veterans." Even though the British took over the town, it wasn't done easily, and the men fighting in Petersburg showed that they could not only fight courageously but slyly.

Despite brave defendants, the effects on Petersburg itself were devastating. "Everything valuable was destroyed, and the wealth of this town in a few hours disappeared," according to General Henry Lee. The British, however, claimed that little was destroyed other than a single warehouse. No doubt the Virginians exaggerated to some degree in an attempt to vilify their pursuers through some effective propaganda.

General Phillips returned to Petersburg in May to await troops of Lord Cornwallis coming up from the south. On May 10, 1781, the Marquis de Lafayette shelled the British from Archer's Hill in what is now the neighboring town of Colonial Heights. Phillips, who was ill, possibly with yellow fever, complained that the Americans wouldn't let him die in peace. A few days later, he did expire and was buried in Blandford Cemetery near the church. Though the exact location of the grave has been lost, a stone marker commemorates his death and his status as the highest-level British officer to be buried not on British soil.

After Phillips' death, Benedict Arnold became commander of the British troops in Petersburg until Cornwallis arrived. Few palpable records of day-to-day life under British occupation exist today. It has been noted that British soldiers were quartered both at the Golden Ball tavern, likely the town's oldest, and at campsites on the grounds of Battersea, Bannister's mansion.

While expansive, plantation-style homes began to emerge close to downtown Petersburg, not all visitors thought much of the common areas used by the majority of the population. One Josiah Flagg wrote in 1786: "This is the most dirty place I ever saw. The Virginians as a people are given to luxury and dissipation of every kind, and are supported in their Extravagance by 'Afric's' sable sons...What is the Reason that so many merchants are induced to Establish Houses there and sacrifice their health?"

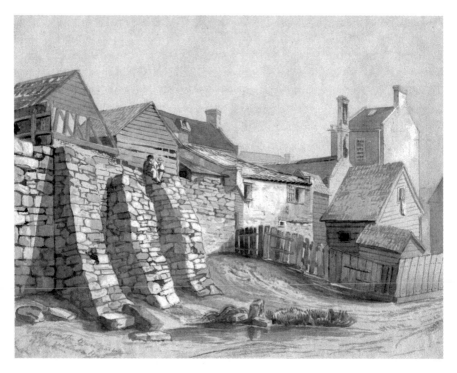

An early backyard scene near High Street shows the density of early housing and the extensive use of stone in construction of walls and basements. Beside the Appomattox River, the stone-lined waterway known as the Brick House Run ran through town, and parts of it can still be seen in various places near Bank and Old Streets. *Courtesy of Petersburg Museums.*

Despite Flagg's appraisal, Petersburg became the antebellum place to set up shop in any number of endeavors. As Noah Webster noted, "It seems to be the taste of the Virginians to fix their churches as far as possible from town and their play houses in the center."

Many grand and modest houses of the later eighteenth century and early nineteenth century remain to this day and may well have been visited by Poe and his bride. Robert Bolling's Centre Hill mansion, built in 1823; Strawberry Hill, circa 1800; and the Trapezium House represent the diversity of the city's antebellum past. The latter, built in 1817 by Charles O'Hara, contains no parallel walls, allegedly because O'Hara was told by his West Indian servant that such a design would ward off evil spirits.

Like any burgeoning industrial town, Petersburg displayed fine houses on one street, with tobacco warehouses, mills, workers' shacks and boatyards on the next. Industry, particularly flour mills, nestled close to the river, while offices

for tobacco merchants, attorneys, doctors and coach makers clustered in the small central downtown. Booksellers, haberdashers, potion sellers, coffeehouses, taverns and furniture makers were all found within a short walk through town. There was also an abundance of artisans, black and white, involved in the fine details within local homes, as well as the building of furniture and coaches.

The indigenous population was an anomaly for any southern town and included the largest free black concentration in the region. In 1800, the population totaled only 3,521 people. Of these, 1,606 were white, 1,487 were slaves and 428 were free African Americans. By 1820, the population had grown to 6,690. Of these, 3,097 were whites, 1,165 were free blacks and 2,428 were slaves. By 1830, the numbers again shifted; the white population totaled 3,440, free African Americans grew in number to 2,032 and slaves totaled 2,850.

While the number of slaves appears large, it doesn't necessarily reflect the true percentage of the overall population found elsewhere in the South. Because Petersburg included the South's largest free black population, families often "purchased" a friend or relative, who would on paper be recorded as a slave. In essence, this freed the individual. But there were other motivations as well. Since the labor or productivity of free black craftsmen or merchants was taxed at a higher rate, families could effectively beat the system by letting the "owned" individual work, as if he or she were part of the slave labor force, and avoid the penalties of freedom on paper.

Petersburg's involvement in the War of 1812 gave birth to the city's nickname, the "Cockade City." In October 1812, 103 men known as the Petersburg Volunteers, commanded by Captain Richard McRae, headed for Canada to fight the British. For months they had been drilling and preparing in what is now Poplar Lawn Park, cheered on by the locals and adorned with red cockades in their hats. Once en route, they were wined and dined in Charlottesville by Thomas Jefferson. It wasn't all preparation and parades, however. Once engaged, they proved themselves on the battlefield and developed such a reputation for fighting valiantly that President James Madison later called Petersburg, their home turf, the "Cockade City of the Union."

TURF AND TAVERNS

Antebellum Petersburg was well known throughout the region for tobacco, flour, horse racing, theaters and taverns. It was, for more than half a century, the veritable center of horse breeding as well as racing. After the

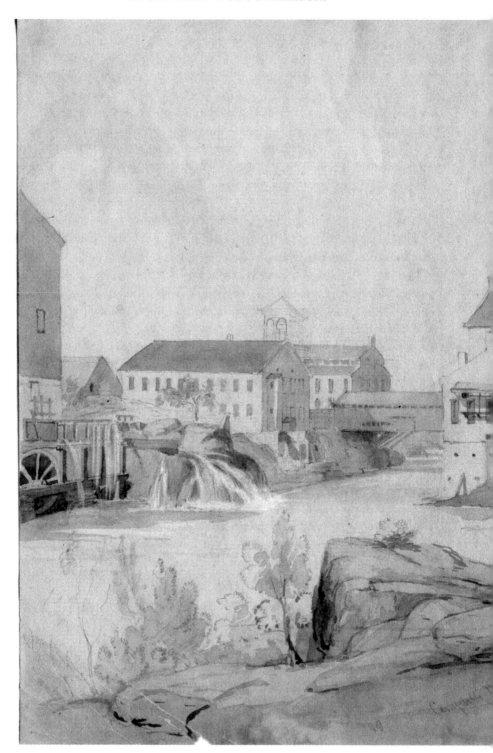

Revolution, turf racing's center moved from Northern Virginia to the south side of the state, with Petersburg as a hub. At least four courses operated in Petersburg or areas nearby, including Pride's, which was in existence as early as 1751. Gillfield ran near what is now West Washington Street, and Ravenscroft, or Poplar Springs course, was close to what is now the historic Poplar Lawn Park.

The most popular course was Newmarket, slightly east of Petersburg in Prince George County. Newmarket was described in an 1829 magazine as "the oldest and most popular club in Virginia; its races are over a course, one mile in length, of good soil for running, and commanding and extensive and beautiful prospect in every direction; they commence, regularly, the first Tuesday in May and the second Tuesday in October."

Advertisements for these courses, and the horses and jockeys scheduled to run, appeared regularly in

Campbell's Bridge, which crossed the Appomattox, connected trading and manufacturing plants on both banks of the river. Confederate forces later destroyed the bridge during the Civil War. *Courtesy of Petersburg Museums.*

the newspapers of the time. The Newmarket races were gala events that brought turf men, spectators and gamblers from throughout the region. This provided regular boons to local inns, taverns and theaters, contributing greatly to the town's growth.

Whether they were called taverns, inns, coffeehouses or restoratives, places to eat, drink, socialize and bed down for the night proliferated in early Virginia. As a commercial hub, milling center and headquarters for the tobacco industry, Petersburg offered plenty of places that buyers, sellers and tourists could call home for the night. While today the state is highly involved in regulating liquor sales, early taverns were free to deal not only in food and drink but potions, medicines, tobacco, souvenirs and sundries as well.

In the late eighteenth and early nineteenth centuries, more than twenty identifiable establishments kept busy within an area of less than a square mile in Old Towne. In nearby Blandford, adjacent to Petersburg and separated by a small creek, another six were at hand for those not wanting to be in the heart of town.

Anyone wanting to open an inn, hotel or boardinghouse faced a relatively easy process, especially compared to the highly regulated Virginia of today. A potential proprietor furnished a small bond to ensure that order would be maintained. As late as 1825, eighteen dollars was the usual yearly tax for a house of public entertainment; four and a half dollars was assessed against the keeper of a house of *private* entertainment. (Historians' assumptions are that the latter were simply boardinghouses.)

One quirk in the stipulations was that the tavern keeper was compelled to forego any political aspirations—he could not hold public office. It was perfectly acceptable to be an opinionated newspaper editor such as Hiram Haines, but seeking public office was strictly taboo.

While the rules of running a public house were kept simple, town hall, as early as the 1780s, did regulate prices in what might be interpreted as an early form of consumer protection. The typical rates for the year 1786, for instance, were as follows:

Dinner with Toddy, small beer or cider	2 shillings, 6 pence
Supper with Same	2 shillings
Breakfast	2 shillings
Lodging	1 shilling
One quart of toddy made of best India Rum and white sugar	15 pence

Porter, per bottle	2 shillings
Claret	3 shillings
Madeira	5 shillings
Cider, per quart	4 pence
Stableage per night or 24 hrs	6 pence
Pasturage per night or 24 hrs	6 pence

With prices kept consistent among businesses, the competitive edge was gained through level of service and the quality of food and accommodations, which, in Petersburg, tended to vary greatly. Wherever you stayed, it cost you more to park your horse for the night than to house yourself, probably because you'd be sharing your lodging with numerous others.

Benjamin Henry Latrobe, English-born architect of the U.S. Capitol Building under Thomas Jefferson, recorded his impressions of Virginia's society, manners, politics and topography in eleven journals written between 1795 and 1798. While attending the many horse-racing venues around town, Latrobe stayed in Armistead's Tavern on Sycamore Street, across the road from Petersburg's current courthouse, which was not completed until 1839. In April 1796, Latrobe wrote: "The accommodation at Mrs. Armistead's are quite good as you ought to expect at such a time as this: I slept in a garret with seven other Gentlemen. Their different merits at snoring I could descant upon at great length, having been a wakeful Listener the greatest part of the Night."

Continuing to find humor in the situation, Latrobe depicted an interesting vignette about the presence of soldiers:

I have neither books, pencils, brushes nor colors, nor any other drawing materials at this place, and my refuge from ennui drinking and gambling is reduced, as you see, to a sheet of bad paper and my pen. Having once lived in a Polish Alehouse for four days, during a fair which had collected all the Jews and Gentiles from 50 miles round under one miserable roof, I cannot say that my residence at Mrs. Armstead's tavern in Blandford affords any scenes that are entirely new to me. The multitude of Colonels and Majors with which I am surrounded brings back the Nobles of the Polish Republic to my recollection, whose power and respectability is much upon the same level. The only difference is, that instead of Count Borolabraski, and Leschinski, and Zetroblastmygutski, and Scratchmypolobramboloboski, and Saradomoschittigurrelkowski, we have here Colonel Tom, and Col. Dick, and Major Billy, and Col'n. Ben, and Captain Titmouse, General

Rattlesnake, and Brigadier General Opossum. The rabble in leather breeches which fills up the vacuities of swearing and noise is scarcely distinguishable in the two places; only indeed by this difference, that we are here at a loss for even a Jewish Rabbai to help out the appearance of Religion, and a box of lemons and sealing wax to represent commerce.

Just a few years earlier, in 1791, Armistead's had enjoyed the distinction of hosting a dinner for George Washington and judges of the District Court. An address delivered to Washington upon his arrival was one of the first, if not *the* first, officially recorded references to the president as "the father of your country."

Armistead's Tavern continued to be a popular place to dine, meet or sleep for many years. In 1804, it was leased, then sold, and became Powell's Tavern, which hosted a banquet for Aaron Burr in the same year. While ownership changed again in 1826, the name remained the same until a fire destroyed the structure just prior to the outbreak of the Civil War.

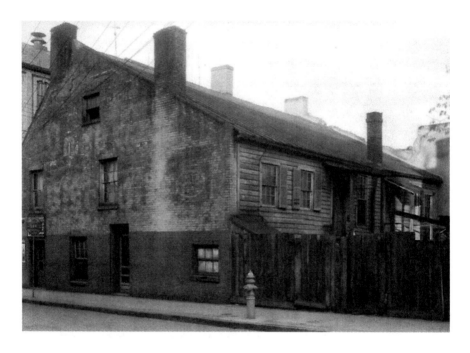

The Golden Ball tavern was one of the oldest in Petersburg, established in 1760. British officers were housed here during the Revolutionary War, and government officials held meetings here regularly until the place began to fall from favor in the 1820s. Newer hotels simply had more to offer in better locales. The building was demolished in 1944.

Among the many other early taverns of Petersburg, the Golden Ball, likely the oldest, occupied the lot at Old and Market Streets. Dating back to the mid-1700s, the tavern, owned by William Durrell, housed British officers during the 1781 occupation of the town. In 1784, the Petersburg Act of Incorporation designated the Golden Ball as the temporary center of official activities. In time, the place suffered from the competition of newer establishments like Armistead's, as well as shifting residential and business districts, and fell from favor as the place to be in Petersburg. By the 1820s, the proprietor, Tench, installed a metal gong on the street in front of the tavern. At noon, a mechanical black man struck the gong with an iron mace in a daily last-ditch ritual geared to gain the lunch trade. By the 1940s, the building had been demolished, but the ground beneath now yields small treasures that predate the mechanical man, the Brits and even the earliest settlers.

Niblos Hotel or Coffee House Exchange was another popular stomping ground in old Petersburg as activity began to spread out from Old Street and Grove Avenue in the early 1800s. One of the city's earliest post offices was housed therein, and when the elderly Lafayette crossed the Appomattox to enter Petersburg during his celebrated visit to America in

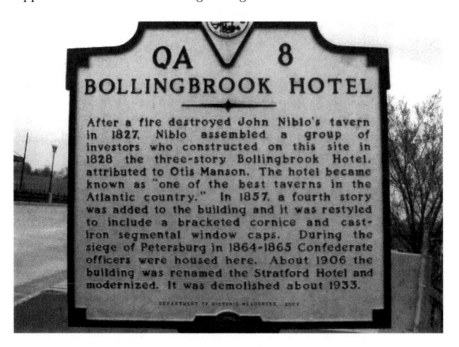

The marker indicating the site of Bollingbrook Hotel, Petersburg's premier place to stay in 1828, after the popular Niblos Hotel had burned down a year earlier.

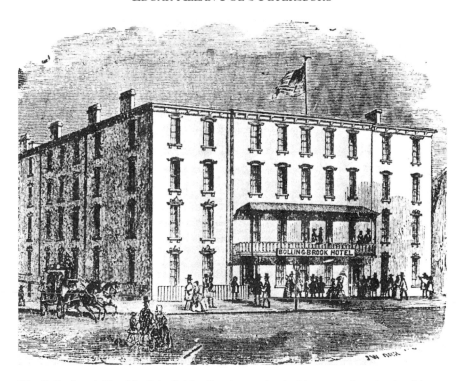

The Bollingbrook Hotel, built in 1828, offered a new level of luxury and service for visitors to Petersburg. Servants wore livery, and single women were invited to drink and converse in their own special apartment. Known by other names in later years, the building was razed in 1932.

1824, Niblos was the site of a grand reception (see chapter five). Having met a young Edgar Allan Poe the day before in Richmond, Lafayette was read a poem of welcome from the young local poet named Hiram Haines, one of the central characters of this story.

Niblos Hotel burned to the ground in 1827. A year later, after a substantial insurance settlement, John Niblos became the primary stockholder in the larger, grander Bollingbrook Hotel at the northeast corner of Bollingbrook and Second Streets. Niblos openly courted female customers by offering them their own "apartments" in which to socialize. Servants wore livery of white with green military caps adorned with tassels. The elegance was disturbed just prior to the outbreak of the Civil War, however. On Bollingbrook Street, near the hotel, the only Secession Pole ever to be erected in Petersburg, bearing the "bonnie blue flag," was hoisted up and then pulled down within hours by an angry mob. The town was strongly Unionist until President Lincoln issued his call for

troops. At that point, the Petersburg delegates to the Virginia Convention finally cast their votes for secession.

Dodson's Tavern on High Street, one of the few period establishments still standing and beautifully restored, is best known today as the place where Aaron Burr and his daughter Theodosia sought refuge in 1804 after the debacle that left Alexander Hamilton dead.

Other taverns and coffeehouses proliferated in antebellum Petersburg, including Eggleston's Old Tavern, James Bromley's, Jallan's, Ferris' and Worsham's, all on Old Street. Convenient to the Back Street Theater on what is now East Bank Street were the Double Inn and Hawthorn & Denhart's Tavern.

On Bank Street, Thweat's Tavern, of 1818, supplemented its income by offering etiquette lessons in its School of Polite Manners and Dancing. Also on Bank Street, Hannon's Tavern was apparently opened by Richard Hannon, a former owner of the Powhatan Plantation and a developer who created many of the newer brick structures in Old Towne as the War of 1812 wound down. Two hundred years later, one of Hannon's buildings, now No. 12 West Bank Street, survives to become the focus of this book. Hannon's brick structures were built to high standards, likely contracted out to John Baird for the actual work. Their brick bones and lathe and plaster walls were accented by ornate moldings and fireplace mantels handmade by the finest craftsmen in Petersburg. Elegant interiors provided an upscale residence for whoever ran the business on the main floor, as well as third-level rooms for boarders.

Not long after No. 12 was completed, it was leased by a popular French emigrant named Richard Rambaut as a luxury hotel with a coffeehouse on the main level. Most of the businesses in Petersburg were in fact leased, at reasonable long-term rates, by owners who may have been as far away as England. Hannon sold the building to an investor named Dickson in London, while back in Petersburg it became Rambaut's Hotel and eventually Hiram Haines' Coffee House, the site of Poe's honeymoon.

CHAPTER 3

ELIZA POE SETS THE STAGE

Theater played an important role in eighteenth-century Petersburg. While at least one part-time informal theater existed in town during the British occupation, the birth of serious playhouses occurred in 1790 when Thomas Wade West (1745–1799), actor and theatrical producer, arrived in Philadelphia from England and formed a company of actors to tour southern towns. West built five theaters in America: Norfolk, 1782; Charleston, South Carolina, 1793; Petersburg, 1796; Fredericksburg, 1797; and Alexandria, 1797. His wife, Margaret, was an accomplished and popular actress who often held the lead roles in companies created to play these venues.

The Back Street Theater that West established in Petersburg on what is now East Bank Street foreshadowed Edgar Poe's ongoing relationship with the town through performances given by his mother, the actress Elizabeth (Eliza) Arnold Poe. At a time when acting as a profession was still of questionable virtue, especially in New England, the petite and pretty Eliza Poe managed to win the hearts of audiences up and down the eastern coast, largely through her lovely singing voice.

At the age of nine, Eliza sailed to Boston from England with her widowed mother, Mrs. Elizabeth Arnold, whom the Boston papers later described as a tall and graceful woman in her mid-twenties. Mrs. Arnold was an actress and singer from the Covent Garden Theatre in London, where Charles Powell, the manager of Boston's new Federal Street Theatre, had discovered her. American theater managers often did their recruiting from the London stage, where the best-trained and most experienced players could be found.

Theaters were a growing business in late eighteenth-century America, despite ongoing Puritan opposition; a competitive free market constantly demanded new talent.

Unlike today's theater productions, long-running plays or musicals were unknown in the late 1700s. There was simply no audience to support repeat performances. To survive, theaters found it necessary to offer constant variety. Actors often were required to learn up to fifty or so stock parts so they could fill a role quickly with little warning. In a season of fifteen to twenty weeks, a theater would regularly produce over one hundred different forms of entertainment, including plays, farces, operas and pantomimes, usually for three nights a week. While the American audiences were decidedly different than those in Europe, Mrs. Arnold's performances were well received.

One of the perks of acting was the fact that every actor was entitled to one "benefit" of the season. Once the house's expenses were covered, all the proceeds for the night would go to the chosen performer. While a profit was not always certain, a benefit for Mrs. Arnold on April 15, 1796, was unusually successful, and not only because it proved that she enjoyed an appreciative following. On this particular night, between plays, she led her little nine-year-old onto the stage before the candle footlights to perform for the first time, singing a new song, "The Market Lass." Only three months after arriving in America, young Eliza Poe was ready for the stage. Eliza performed regularly with her family in Boston and then Portsmouth, Maine, where she established herself as not only a singer but a precocious young actress as well.

MARRIAGE TO TUBBS

In 1796, Elizabeth married a musician, Charles Tubbs, who had sailed with her and her daughter from England. The new family joined with a manager named Mr. Edgar to form a theater troupe called the Charleston Comedians. In Charleston, South Carolina, a sophisticated and wealthy city, Eliza performed her first substantial leading roles under the tutelage of her new stepfather, but his personal disputes with others in the company eventually forced the family to move on. The solution was found with theater entrepreneur Thomas Wade West's Virginia Company, which played a year-round circuit that included Norfolk, Petersburg, Fredericksburg, Alexandria and Richmond.

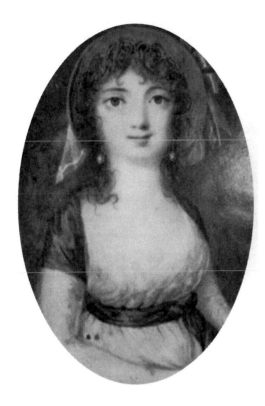

The only surviving image of Poe's mother, Eliza. This miniature was painted by Thomas Sully when she was sixteen years old. Sully was part of a well-known family of actors and artists with roots in Petersburg. *Courtesy of the Edgar Allan Poe Museum, Richmond.*

As they had done in New England, the small troupe of players offered performances in small towns in which they stayed along the route north. By mid-July 1798, they had made their way to Halifax, North Carolina, just south of the Virginia state line, accompanied by some of the actors who had played with them in Charleston.

While staying at Colonel Tabb's Tavern, performances were cancelled when Mrs. Arnold became ill. Sadly for young Eliza, Elizabeth died, likely of yellow fever, which had reached epidemic proportions on the East Coast. One can only imagine the effect this had on the eleven-year-old girl. She lost not only her mother but her closest acting companion and teacher as well. She also was left to travel the rest of the long journey with her grieving stepfather, who was known to be temperamental and unstable at best.

Farther north, West's Virginia Company finished its summer run in Fredericksburg and headed south to Petersburg for a short fall engagement before heading back to Richmond for the winter. Eliza and Tubbs spent the winter season performing in the temporary theater in the city's Market Hall.

In Petersburg, West's company of actors included strong local connections, including his brother-in-law Matthew Sully. Others in the troupe were West's wife, Margaret; her daughter; the greatly admired comedienne Anne West; and William and Hope Green. Matthew Sully was part of a well-known family of actors, artists and portraitists that stretched over several generations. His son, Thomas Sully, established himself as one of the premier portrait

painters of the nineteenth century. Thomas' nephew Robert Sully, born in Petersburg in 1803, moved to Richmond, where he later became friends with Edgar Allan Poe when both were children. As an adult, Robert painted an idealized portrait of Virginia Clemm from memory and is also credited with having done a portrait of Poe that mysteriously disappeared. These seemingly serendipitous connections are perhaps simply an indication of how small the world and the Petersburg-Richmond region were at the time.

While her mother was no longer present to guide her career, Eliza displayed the same keen talent and timing as her mother, and she procured numerous roles that suited her in the eyes of critics and audiences alike. One of the more impressive venues was the Chestnut Street Theater near Independence Hall in Philadelphia, which seated two thousand patrons. There she met a young, talented actor named Charles Hopkins. After the close contact lent by endless rehearsals and performances up and down the coast, the two inevitably fell in love and married in the summer of 1802. Eliza was only fifteen.

The young actress and her company traveled overland by stage, which meant long and exhausting days of bumpy roads beginning at daybreak and ending at nightfall in taverns en route, where a young married couple would have been lucky to have enjoyed any privacy at all. Stage passengers usually had no choice as to where they would spend the night. Travelers through Virginia would be taken in by planters and might enjoy sumptuous hospitality. Life on a plantation could be monotonous, and lonely owners would invite complete strangers into their homes, sending servants to extend invitations to them in a nearby tavern or even on the road. For actors trying to maintain a schedule, this could mean delays as plantation owners pressed their interesting guests to stay. But the comforts of plantation life were hard to turn down.

A Presence in Petersburg

In early November 1802, Eliza and Charles reached Petersburg. At the time, the population was slightly less than four thousand, which included numerous slaves. Still, a larger transient population was ever present since the town was a horse-racing center as well as a shipping port. The races were not only popular but also fashionable, ending with the Race Ball. During the spring and fall racing seasons, the town took on a festive carnival air, with people flowing in from miles around.

Margaret West had established *the* acting company in town at the Back Street Theater. In order to earn a place in the company, Eliza learned a number of new parts immediately, including that of the role of Zelina in the premiere of a new play, *Oberon, or the Siege of Mexico*. This new production was of particular interest to locals since the playwright, John Daly Burk, lived in Petersburg a few blocks from the theater. Burk was the author of *The Battle of Bunker Hill* (the second production in which Eliza, as a child, had made a brief appearance at the John Street Theater in New York). Though he was best known as a playwright, Burk, like many other Petersburgers, pursued numerous vocations, including that of lawyer, historian, orator, poet and newspaper editor. The success of *Bunker Hill* inspired him to write several other plays, including *Oberon*.

Oberon opened under typical circumstances—costuming problems, under-rehearsal and unfamiliarity with the new script. The reviewer for the *Petersburg Republican and Advertiser* was characteristically unabashed:

> *The opening of the play with the introduction of a drummer and trumpet, in a contest of lungs against arms, is a new thought; had these gentlemen left their instruments behind the scenes, they would have appeared to more advantage...The earthquake or temple scene might have had a good effect if anything like a storm had been exhibited; but as it was, the audience would not have known what it was intended for, had not the mother of Oberon been kind enough to give a description of it to her son.*
>
> *After saying thus far of what we suppose to be blemishes of this piece, we feel a pleasure in acknowledging, that many of the scenes are strongly delineated...the last of these scenes had a powerful effect on the sympathetic feeling of the audience.*

This reviewer gave high praise to Eliza and Charles, despite the shortcomings of the play's production values: "The pleasing manner in which Mrs. Hopkins performed the part and such the songs of Zelina had a very good effect," he wrote, and "Mr. Hopkin's [*sic*] performance of Ratta and Caustic, were in the best style of acting. "

This reviewer's assessment, which found the acting far superior to the actual production, was typical. Thomas Wade West had recently died, and while his wife was an accomplished actress, she was never able to create the special effects for which her husband was well known.

Based on the records that survive, it is clear that Eliza played the regular fall seasons in Petersburg, as well as Fredericksburg. A Petersburg advertisement

of Saturday, November 12, 1803, promoted a benefit for the Hopkins couple at the Back Street Theater. This marked the first record of Eliza's appearance in Richard Brinsley Sheridan's eighteenth-century comedy *The School for Scandal*. Since it was their benefit, both Eliza and Charles sang between the play and the after piece, and Eliza also appeared in a solo dance.

In 1804, Eliza's season in Petersburg was longer than usual. A major fire in Norfolk had destroyed most of the city and prevented the company from putting on its usual late spring engagement. Rather than be idle until the fall season, Mrs. West kept the troupe in Petersburg for several extra weeks during the spring races. In order to attract audiences for this extended stay, the company produced a number of new plays, including a new comedy by Charleston playwright James Workman called *Liberty in Louisiana*. Eliza and Charles became well known during these days in Petersburg, and by the end of the stay, they presented a concert of their own in appreciation of the local audiences.

By July, the couple was back in the Richmond Company for the summer season at Quarrier's temporary theater. The opening play was Thomas Morton's comedy *Speed the Plow*. Eliza and Charles both held important roles, as did a new, young actor who had just joined the company. His name was David Poe.

The nineteen-year-old David Poe had very possibly seen the well-known couple before, most likely at the Holiday Street Theatre in Baltimore, where he lived with his family and had been an avid theatergoer. Poe had only recently played his first professional engagement, having given up the pursuit of a law career, much to the disappointment of his father, Major David Poe Sr. The elder Poe was a Revolutionary War hero, friend of the Marquis de Lafayette and often referred to as "General Poe" by the people of Baltimore.

The young David Poe was good looking, with a good voice and an ability to recite poetry with flair. But he suffered from terrible stage fright that resulted in his rushing through his speeches and, often, an inability to remember his lines. Somehow, he survived. Though overshadowed by more experienced cast members like Eliza and Charles, he made it through the season.

In mid-October, the future father and mother of Edgar Allan Poe and her then-husband, Charles, found themselves in Petersburg again for the customary fall season during the races. The Back Street Theater was crowded on opening night as a new play, *The Soldier's Daughter*, proved to be an enormous success, garnering high praise from the *Petersburg Intelligencer* for the performances of both Mrs. West and Mrs. Hopkins (Eliza).

Soon after the opening, the company began rehearsals for *Bethlem Gabor*, the second of Petersburger John Daly Burk's plays to be produced in

Petersburg by Mrs. West since Eliza had joined her company. The public's interest in the local production of this melodrama was soon overridden by more interesting news—the arrival of Aaron Burr. It had been three months since his fatal duel with Alexander Hamilton, and Burr was under indictment for murder in New Jersey and New York. He had fled south immediately after the duel and was traveling through Petersburg on his way back to Washington. He was still serving the final year of his term as vice president.

Petersburg welcomed Burr with characteristic hospitality, and he was wined and dined in style. On Tuesday, October 30, he was escorted to the Back Street Theater, where the Virginia Company played a performance of its successful hit *The Soldier's Daughter*, with Eliza, Charles and David all in the company. When Burr was introduced in the theater, he received a standing ovation.

Like for her son many years later, tragedy as reality would bring more hardship to Eliza than any fictional plot. Charles died in 1805, likely of yellow fever, just like her mother. In 1806, just six months after Hopkins' death, Eliza married her ardent secret admirer, David Poe Jr.

Eliza and David continued on the circuit, playing theaters in New York and Boston. Eliza, now with many years of experience behind her, was well received, while David's inexperience and obvious stage fright worked against him. The company they worked within was twice as large as what they were used to in Virginia.

Boston initially proved to be an ordeal for the couple; they were cast in major roles in *King Lear* (the altered version popular at the time), and Eliza gave birth to their first son, Henry. Reviews for both Eliza and David were mixed. One critic noted that as Vernon in Shakespeare's *Henry IV*, David had "mutilated some of his speeches in a most shameful manner."

Eliza's singular talents gained much admiration and acclaim for her role in the most successful, lavish production with which she had ever been connected—*Cinderella*. David was cast as the Prince and Eliza was cast as Venus, both pivotal roles in what was touted as a spectacular production with "new and splendid scenery, machinery, dresses, and decoration."

The same month that *Cinderella* opened at Boston's Federal Street Theater (December 1808), Congress passed the Embargo Act, forbidding American exports to Europe. Since the seaport was one of the busiest in the country, idle ships soon crowded the harbor. Eliza walked down to the harbor, created a sketch of the anchored clusters of ships and noted with a caption: "Morning 1808." She hung onto this drawing and eventually inscribed it with one of the few personal records of her abbreviated life: "for my little

son Edgar, who should ever love Boston the place of his birth and where his mother found her best and most sympathetic friends."

In Boston, Eliza continued to be challenged by newer, more demanding roles. On the day she was to perform the benefit on behalf of herself and David, the *Gazette* published an editorial that tells us as much about her abilities as any:

> *If industry can claim from the public either favor or support, the talents of Mrs. Poe will not pass unrewarded. She has supported and maintained a course of characters, more numerous and arduous than can be paralleled on our boards, during any one season. Often she has been obliged to perform three characters on the same evening, and she has always been perfect in the text, and has well comprehended the intention of her author.*
>
> *In addition to her industry, however, Mrs. Poe has claims for other favors, from the respectability of her talents. Her romps and sentimental characters have an individuality which has marked them particularly her own. But she has succeeded often in the tender personations of tragedy; her conceptions are always marked with good sense and natural ability.*
>
> *We hope, therefore, that when the united recommendations of the talents of both Mr. and Mrs. Poe are put up for public approbation, that that public will not only note discountenance virtuous industry and exertion to please but will stretch forth the arm of encouragement to cheer, to support and to save.*

According to newspaper accounts, Eliza and David spent most of the summer of 1808 in Petersburg, appearing from time to time with a number of their friends in short plays, setting up performances wherever they could find an audience. More regular employment came with a return to Boston in the fall at the Federal Street Theater. The one hindrance to her usual versatility was the fact that she was increasingly pregnant. Still, she continued to perform until January, and within two weeks after stopping she gave birth to her second son, Edgar, at the house of Henry Haviland, south of the common near the Charles River.

The months that followed were marked by continued successes for Eliza but sporadic disappearances by David. Often, it seems anecdotally, he was seeking money from friends and relatives. When he returned, the couple found their way to New York to perform at the Park Theatre, where, as usual, Eliza was greatly applauded. But a young critic for a new literary magazine called the *Rambler* singled out David as a particularly vulnerable

target for verbal abuse. On one occasion, David had to fill in for the normal player, Hopkins Robertson, a popular leading actor at the theater, because he had taken ill. The *Rambler* immediately took notice:

> *Mr. Poe was M.R.'s substitute in Alonzo; and a more wretched Alonzo we have never witnessed. This man was never destined for the high walks of the dram;—a footman is the extent of what he ought to attempt; and if by accident like that of this evening he is compelled to walk without his sphere, it would bespeak more of sense in him to read the part than attempt to act it;—his person, voice, and non-expression of countenance, all combine to stamp him—poh! Et praeterea nihil.*

Comments by the *Rambler*'s sole critic were not only harsh but also often unfair. They became personal to the degree that other papers did come to David's defense. Shortly after these series of incidents, David's career as an actor abruptly ended.

His actual whereabouts during this time are not documented. He may have simply been playing househusband with the two children, or he may have left the family for a time. What is known is that Eliza's career continued to flourish as she acted in the East Coast circuit, including New York at the Park Theater, where she often appeared with Thomas Cooper, one of the foremost leading men of the time. Her substantial repertoire included more than seventy roles that she could play at a moment's notice.

In the early summer of 1810, she joined the Placide-Green Company in Petersburg, where she was able to work with old friends at the Back Street Theater. William Green, whom Eliza had known for many years, and Alandre Placide jointly managed this company, which moved on to Richmond later in the summer for the fall schedule. Margaret West had died in Norfolk, bringing the Wests' twenty-year control of the Virginia circuit to an end. Placide, a flamboyant actor and acrobat, would become one of the most important figures in early American theatrical history.

Eliza's seemingly inexhaustible versatility continued to shine in Norfolk. There, as evidence that David had not completely parted the scene, she gave birth to her third child, Rosalie, in a Norfolk boardinghouse.

Within a month, she was back at work, this time in Charleston, where she had not performed for thirteen long years. She regularly performed in *The School for Scandal*, *The Rivals* and *The Wonder*, in which she continued to prove her versatility and prowess as a comedienne. She also sang in two concerts at the Church Street Theatre.

Actor Matthew Sully, of the Petersburg Sullys, who had known Eliza since they were both children in the Virginia Company, had become very well known in Charleston through the years. When it was time for his benefit, he fared well. Eliza's subsequent benefit also yielded a much-needed profit.

But the workload in Charleston was strenuous, and Eliza began to show signs of exhaustion. The physical and mental energy required for learning, rehearsing and playing twenty-five new roles, along with those already in her repertoire, was wearing her out. In addition, there were the constant responsibilities of motherhood, especially with the new baby Rosalie. Her husband, by this time, was gone. Her son Henry was sent to Baltimore to live with his grandparents. Rosalie and baby Edgar remained with her.

During the hot summer season in Norfolk, it was becoming apparent to the newspaper people that she was under great strain. When time for her benefit came, the *Norfolk Herald* printed a letter praising her abilities, as well as how much she had done for Norfolk theater, but added: "Misfortunes have pressed heavy upon her. Left alone, the only support of herself and several young children—Friendless and unprotected, she no longer commands that admiration and attention she formerly did…And yet she is as assiduous to please as ever, and tho' grief may have stolen a few of the roses from her cheeks, still she retains the same sweetness of expression and symmetry of form and feature."

After Norfolk, Eliza and the remnants of her family returned to the familiar territory of Richmond and Petersburg, where she was well known and admired. Despite the fact that she has been depicted as a destitute and forgotten performer in many Poe biographies, she was far from living on the street. Still, her mental and physical health were highly compromised.

DISORDER AND EARLY SORROW

Petersburg likely marked another turning point in Eliza's destiny. In October 1811, the Richmond Company closed briefly for a short engagement in Petersburg during the height of the races. When she returned to Richmond, she was seriously ill. Having traveled the hot breeding grounds for disease, she may well have been stricken with malaria, then referred to as "ague and fever." Considering the stress she was under, as well as that of having given birth, her immune system was certainly compromised, subjecting her to any number of deadly diseases.

For up to six weeks, she lay in a boardinghouse near the Washington Tavern on Ninth and Grace Streets, where she and other actors often stayed. Her many friends, co-workers and admirers knew that she was slipping away.

On Friday, November 29, her fellow actors gave her a special benefit, and above their notice in the *Virginia Patriot* they placed this announcement:

> *Mrs. Poe's benefit*
> *In consequence of the serious and long continued indisposition of Mrs. Poe, and in compliance with the advice and solicitation of many of the most respectable families, the managers have been induced to appropriate another night for her benefit—Taking into consideration the state of her health, and the probability of this being the last time she will ever receive the patronage of the public, the appropriation of another night for her assistance, will certainly be grateful to their feelings, as it will give them an opportunity to display their benevolent remembrance.*

The *Richmond Enquirer* also carried an appeal for the support of Eliza's benefit: "To the Humane Heart: On this night, Mrs. Poe, lingering on the bed of disease and surrounded by her children, asks your assistance; and asks it perhaps for the last time.—The generosity of a Richmond Audience can need no other appeal. For particulars, see the Bills of the Day."

Eliza clung to life for ten days following her benefit. On Sunday morning, December 8, 1811, she died, leaving three orphans. She was only twenty-four years old.

On a chilly Tuesday morning, she was laid to rest in St. John's Churchyard in Church Hill, in a grave that remained unmarked for over a century. Only Edgar and Rosalie were with her in Richmond when she died. Likely through arrangements made before her death, Rosalie was adopted by the William MacKenzies, and Edgar was taken in, but not legally adopted, by the John Allan family.

No one knows exactly what happened to David Poe, but it was assumed that he died either shortly before Eliza or soon afterward. Henry Poe spent much of his short life at sea but did communicate with Edgar from time to time. He died at age twenty-four, and Edgar described him as "entirely given over to drink and unable to help himself." Rosalie, the youngest child, suffered from arrested mental development but lived to age sixty-three. As Edgar's only living heir, she inherited his personal belongings, some of which she sold.

The Back Street Theater burned down in 1815, along with most of the wooden structures in what is now Old Towne. Some of the brick structures

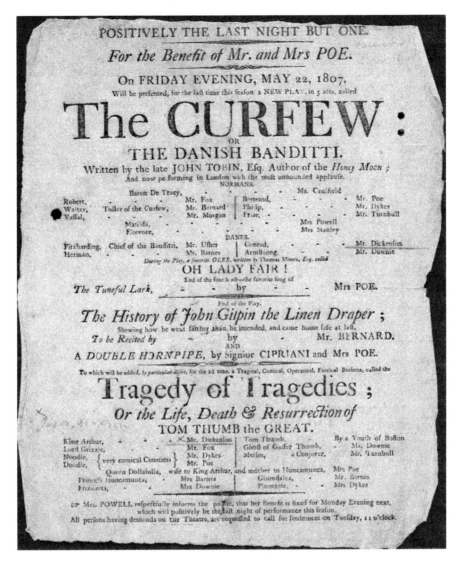

This 1807 Boston playbill promotes one of many benefits for Mr. and Mrs. Poe. At the time, actors regularly subsidized their incomes through benefits given on their behalf. Often, players would sing or create special solo performances as a way to thank their audiences for their support.

survive to this day, however, as do many of the buildings constructed after the fire.

Despite a life spent in London and many of the major cities of the East Coast, Edgar Poe's lifelong connection with Petersburg was solidly established by his mother, who was dearly loved and admired in Southside Virginia. While

his personal connection with the city would be firmly established while he was in his later twenties, a prelude was already beginning in early childhood through a key player in the Petersburg-Poe drama—one of his favorite childhood playmates, Mary Ann Philpotts, future wife of Hiram Haines.

Eliza Poe was not forgotten, however. Despite her untimely demise, she left several legacies. Her son Edgar would eventually be known as one of the greatest, if not the greatest, American writers. And in the streets of Petersburg, aristocrats and common people were known to sing or whistle for a generation what had come to be known as her theme song:

"Nobody Coming to Marry Me"

The dogs began to bark,
And I peep'd out to see!
A handsome young man hunting;
But he was not hunting for me!
And 'tis O! what will become of me,
O! what shall I do

Nobody coming to marry me
Nobody coming to woo!

The first time I went to myt pray'rs,
I pray'd for half a year!
I pray'd for a handsome young man;
With a mickel deal of gear,
And 'tis O! &c.

The last time I went to my prayers,
I pray'd both day and night.
Come blind, come lame, come cripple,
Come someone and take me away.
For 'tis O! &c.

And now I have sung you my song,
I hope it has pleased you well;
That a husband for me you will find,
Or soon you will hear of my knell.
For 'tis O! &c.

CHAPTER 4

THE MILLER AND THE COUNTESS
(AND OTHER LOVERS)

Antebellum Petersburg was not only a prosperous, culturally diverse community but also a city rich with personal stories of adventure and romance. Many of these tales lived on through oral histories and family anecdotes well into the nineteenth century, while by now, most have been forgotten. Among the most remarkable life histories, none stands out like the true story of Richard Rambaut and the Countess Elise de Rochefoucauld. This couple not only proved that love conquers all but also engaged themselves in numerous Petersburg businesses, including the operation of an exclusive hotel on Bank Street. Rambaut's Hotel, elegant and sophisticated, included the rooms where Poe and Virginia would spend their honeymoon under Hiram Haines' proprietorship years later.

Revolution played an important part in Petersburg's early development. Not only the American Revolution, which found Lafayette defending the city against Cornwallis, but also the uprisings in France and San Domingue (now Haiti). The result was an active community of French immigrants in what is now Old Towne, composed of refugees of all colors from France and considerably more from Haiti. Among the most notable was one Richard Rambaut.

Rambaut's name appears time and again in early court documents, deeds and newspaper advertisements. He was, by all accounts, a flamboyant entrepreneur who, while primarily a miller, placed his fingers in any activity

This view looking toward the courthouse on Sycamore Street, completed in 1839, shows that not all of the city was an industrial complex. Trees, rolling hills and walkways helped to make the downtown area a pleasant place to live or visit. *Courtesy of Petersburg Museums.*

that might turn a profit. He bought and sold flour, concocted medicinal potions, dealt in property, partnered in a mill on the Appomattox River and imported goods from Europe in his own warship, the *Betsey*. Rambaut had good reason to involve himself in moneymaking activities and stay in the black: his wife, the beautiful young Marie Elise de la Rochefoucauld, had descended from one of the wealthiest families in France, with large holdings in San Domingue as well.

Richard Rambaut emigrated from a family estate known as Chateau Bunitree, near Bordeaux. Being an aristocrat and Royalist, Rambaut fled the country seeking refuge with relatives in San Domingue when the French Revolution erupted in 1789. He had barely settled in when another revolution overtook the island a year later. His final escape took him to Petersburg.

At the same time, the drama of a beautiful young countess who would come to be known as the Countess Marie Elise de la Rochefoucauld was unfolding. As the only daughter of the Count de La Roche, Elise was born in San Domingue, amidst the island's sprawling plantations. While still an

46

infant, her marriage was arranged to a cousin, the eldest son and heir of the Marquis de Tour La Roche. The fortified town of La Rochelle took its name from this same family.

As a young child, she was sent to the chateau of her uncle to be educated as the future wife of the youthful heir. But it all blew to pieces with the French Revolution. Her uncle was guillotined— but he exited with style. Historian John S.C. Abbott noted that Tour La Roche was widely known as the politest gentleman in France. He allegedly walked on the scaffold with his laced chapeau under his arm and a rose in his buttonhole, for which he had spent his last franc, and bowed to his

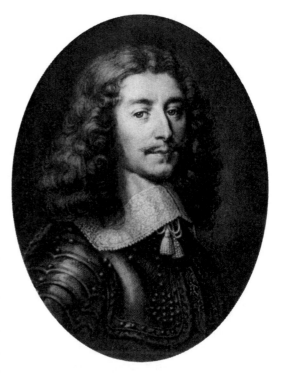

Young Elise de la Roche was married to a direct descendant of the famous French writer François de La Rochefoucauld (1613–1680). Her husband was killed during the slave revolt in San Domingue, which is now Haiti.

executioner. His son, the young marquis, died from "cruelment" and neglect in the infamous prison known as the Conciergerie.

The young countess Elise and her mother managed to escape, however. A faithful black servant named Lucinde, more familiarly known as "mama," and her husband, Jacques, carried their young charge in a cart of soiled clothes to the family chateau in the south of France. There they arranged the countess' escape to England, where she was met by her master, the Count de La Roche.

They all sailed for San Domingue, just as Richard Rambaut and numerous aristocrats had done. The party included Elise's cousin, Eugene de La Rochefoucauld, the direct descendant and heir of the famous seventeenth-century writer François de La Rochefoucauld. He was more distantly related to her than her late fiancé, the young marquis, and as the sole remaining descendants of those two old French nobles, a quick marriage was arranged between them.

San Domingue was an immensely rich and successful colony, built on the backs of the African slaves who laboriously worked the sugar plantations. During the last several decades before the revolution, which began in 1793, there were 350,000 slaves in San Domingue (almost all of them working the plantations), about 30,000 white Frenchmen and 20,000 mulattoes. The colony was so successful that it was full of French aristocrats, intellectuals and scientists. With a constant flow of sailors, the island was also a place of violence, disease and sex, mixed in a pot with bourgeois and aristocratic elegance to produce a culture that was very different from the Anglican world of Virginia.

The newlyweds had scarcely established a household when the insurrection of San Domingo violently tore their lives asunder once again. The Count de La Roche was stabbed to death, and true to form, the faithful nurse Lucinde quickly saved the young duke and his bride from a horrible death. She and her husband found a small fishing boat and smuggled the two onboard. They were picked up at sea by a vessel bound for Baltimore and already filled with refugees fleeing to that popular port of safety.

Elise and her mother and the two faithful slaves were likely picked up by part of a large rescue convoy escorted by the French navy. Most of the sugar plantations of northern San Domingue were burned in the first stage of the revolution. Two thousand French men and women, as well as mulattoes and a few slaves, were carried by a convoy of 140 French vessels from the burning city of Cap Francais (now Cap-Haïtien) to Norfolk. Virtually overnight, it became a predominantly French city. Later, these refugees spread out through the Chesapeake and beyond, with the largest number settling in Baltimore, the major city of the Chesapeake. Others settled in Alexandria, Richmond and Petersburg, as well as along the coasts, including New England, Charleston and New Orleans.

After waiting a short while, Eugene returned to San Domingue in the hopes of securing hidden silver and jewels. Unfortunately, his return coincided with the fatal edict of Toussaint L'Ouverture that all whites should leave the island or be put to death. Eugene de La Rochefoucauld was never heard of again.

Still, he had found enough time to arrange the smuggling of some family possessions to his young wife and her mother, including antique furniture, portrait miniatures set in jewels and a box containing deeds to the estate. He also sent old family letters and records, including the ancient documents from the Crown of France to the Count de La Roche granting the estate to the family forever.

The new small family was not completely alone in Baltimore; there were plenty of other refugees arriving daily. But even if time began to heal the traumas of death and narrow escapes, the loss of their incredible wealth and prestige took its toll. While hopes of a return of the old French monarchy simmered beneath, the realities of life in a new American city had to be dealt with.

Loyal to the end, Lucinde and Jacques supported the helpless countess and her mother by their own hard labor. Jacques was a ship caulker by trade, and his wife had learned to launder and mend lace in pattern in the convent to which she accompanied her young mistress in France. They worked at these trades and made enough money for the daily needs of the four.

But for the kindness of these companions in exile and misfortune, they easily would have perished. Many of the old aristocrats who had known mother and daughter in their days of grandeur remained true and hospitable to them. The Marquis de Mon Monier and Madame La Moricion were the nearest of these. The Chatards, the Carrierres and the Balstranes—names familiar to Baltimore today—were among Elise's kindest friends.

At a party given by another royal in exile, Madame Cirocq, the fates of the countess and her mother, as well as that of Richard Rambaut, would change forever. It was time to put arranged marriages and their catastrophic consequences in the past. It was time for both women to give true love a chance.

Richard Rambaut may or may not have been invited to the party at Madam Cirocq's home, but when he arrived, he encountered what was likely the most beautiful woman he had ever seen. She had been born a countess, betrothed to a marquis, married to the heir of a dukedom, seen both of them slaughtered and then narrowly escaped death herself to live in poverty supported by servants. Yet she was barely in her twenties and retained a beauty that was the talk of the French community.

Proud and highly born, she was not ready to latch on to the first available male means of support either. According to descendants who had seen his portrait from life, Richard Rambaut was handsome, with dark penetrating eyes, ambitious and, if not arrogant, beaming with self-confidence. He, too, had been through a great deal to find himself in Baltimore at the home of Madam Cirocq.

It was, by all accounts, love at first sight. After a brief courtship, the Countess Elise de la Rochefoucauld and Richard Rambaut were married, and she became simply Madame Rambaut of Petersburg, Virginia, before she was twenty-five years of age.

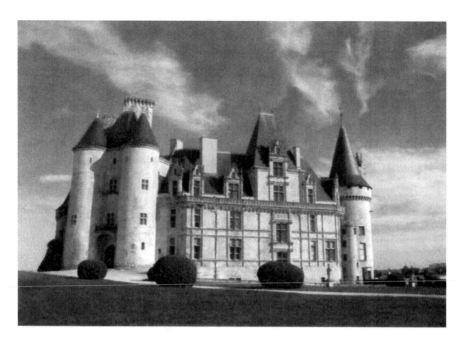

Had it not been for the French Revolution, the Countess Elise would have spent her life as mistress of the Chateau de la Rochefoucauld in Charente, France. While she lived in dramatically different circumstances in Petersburg, she was able to marry Richard Rambaut for love rather than political expediency.

Apparently romance was in the air. Not long afterward, the countess' mother married Captain J.W. La Touche, one of the most eligible and distinguished émigrés in Petersburg. La Touche had been the captain of the greatest vessel in the French navy, the *Ville de Paris*, flagship of the French fleet in the New World. This fleet had successfully fended off the British in the Battle of the Capes in 1781 during the Revolutionary War.

The newlywed Rambauts settled into a house that still stands at 426 Grove Avenue. Mr. and Mrs. La Touche lived right next door. Through subsequent years, La Touche and Rambaut were involved in numerous enterprises meant to bolster their fortunes in booming Petersburg. For the countess' sake, as well as his own, Rambaut was constantly filing claims against the French government for reparation of property they had in San Domingue. These fruitless efforts continued throughout his lifetime.

In 1799, the couple's first child, Gilbert Vincent Rambaut, was born. (Years later, Gilbert's wedding reception would be the subject of a humorous letter written by Hiram Haines; see page 85.) Gilbert Vincent also distinguished himself during the Civil War.

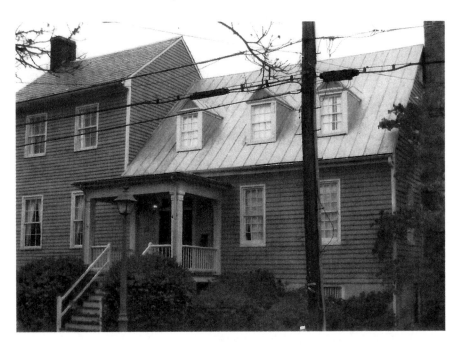

The Grove Avenue home of Richard Rambaut and the Countess Elise still stands and is fully restored. While extremely modest when compared to the castles and plantation homes the countess had known in France and Haiti, it seemed to have served the couple well for having married for love rather than titles.

By 1801, a daughter, Rosetta Eleanor, was born as well. At the time, Rambaut was running several flour mills on the Appomattox, as well as the fancy hotel on Bank Street. He also purchased a 370-ton single-masted ship called the *Jovial Farmer*, which he renamed the *Betsey*, a nickname for Elizabeth (Elise), his beloved wife. He used the boat to shuttle goods back and forth across the Atlantic. Typical of eighteenth-century sloops, the boat was, in fact, a small warship, well armed to provide escort for merchant ships.

According to descendants, Rambaut had received a large estate in San Domingue and $40,000 from a good friend and benefactor named Lewis Julian Hoisnard. Rambaut was able to leave San Domingue with much of the cash. Hoisnard eventually made it to Petersburg as well. The money was invested in Rambaut's various enterprises but also went toward lawyers and court fees in the fight to regain the land he had lost.

Like many Petersburg business owners, Rambaut enjoyed numerous highs and devastating lows as the town's economy went through booms and busts. He clearly took pride in his luxurious hotel (see advertisement on page 53) and provided food, drink and medicines in the street-level "restorative."

At one point, he joined forces with an unusual entrepreneur—a free mulatto woman from San Domingue named Amelie Gallee. Amelie ran a bathhouse and believed heavily in both diversification and advertising. During one of the town's recessions, in the hot summer of 1824, one of her ads promoted some of the things Rambaut was noted for in town:

> *Health—Purchased Cheap!*
> *In consquence of Small Change being scarce, and wishing to contribute towards the health of the ladies and gentlemen, the subscriber has the pleasure to inform her patrons and the public that she has reduced the price of her baths to 25 cents for a single one. She will make no comments on the necessity of Bathing in warm weather—suffice it to say that with Mr. Rambaut's FAMILY MEDICINES, and some Cold or Warm Baths, the health of her friends will keep at a proper degree of the Thermometer, without the aid of Calomel or other minerals Medicines.*

Courthouse records indicate that Rambaut and one of his partners were in debt to a "Gallee woman" who had provided them with financial assistance on several occasions. Rambaut also borrowed heavily from another refugee, Elizabeth Allergue, who came to be known locally as the "French Betsy." She had arrived on the same flotilla that had picked up the two countesses in 1793 and came to own a substantial amount of property in Petersburg. When Rambaut auctioned off many of his belongings in the early 1820s, she was owed roughly $2,600—the equivalent of more than six figures today.

We don't know how much the Countess Elise knew about Rambaut's ups and downs. The Petersburg court records show more than twenty transactions of assorted properties and interests by Rambaut between 1800 and 1823. Clearly he was, at times, juggling accounts while the countess, as far as we know, remained countess-like, certainly enjoying the races and the Back Street Theater whenever the best performers, such as Eliza Poe, were in town. Letters of the time show her presence as a highly sought guest at any of the important fêtes given in town.

Her servant and savior from childhood, Lucinde, apparently remained with her for some time, though somehow through the years, technical ownership apparently went to James La Touche. On Christmas Day 1823, La Touche sold "my Negro woman named Lucinde unto James B. Kendall in trust, to suffer Mrs. 'Eliza' W. Rambaut to have, hold, enjoy & receive the services or profits of the said woman during her life…Lucinde to be in no way subject to

the debts or contracts of the said Mrs. E.W. Rambaut or her husdband in any manner whatever."

This was most certainly a strategic financial move, purely on paper. At some point, Lucinde had gone to La Touche as real property, and now he was giving her back. The woman who had saved the young countess' life was hardly a slave, and La Touche was known to do whatever the Rambauts needed done to keep them solvent and happy.

This strategy could only go so far, however. The so-called panic of 1819 brought financial hardship to many, rich and poor, and for Richard Rambaut, full recovery was too steep a hill to climb. Whether the highs and lows of his financial

HOTEL—AGAIN!

SEVERAL of my Country friends having lately told me, that they did not know that I kept a House of Entertainment for Travellers, I have the pleasure to inform them, and others too, that I keep as good a Public House as any in the State of Virginia; my *Stables* are as good and as well provided as any gentleman's—stable—my *Bed Rooms* are good and clean enough for the President of the U. S. to sleep in—my *Table* equal to any body's table, and the house kept in such an order, as for the lodgers not to be disturbed after they are in bed.—Gentlemen Travellers are invited to make a trial of the accommodations of the house, and if any reasons to complain, '*Liberty & Equality*,' shall be the rules observed by

Jan. 13 R. RAMBAUT.

N. B.—I would call my house *La Grange*, and heartily make it the home of every American, but I cannot afford to do it unless all my visitors pay me their bills—Farewell.

Rambaut's Hotel on Bank Street later became Hiram Haines' Coffee House, where Edgar Allan Poe and Virginia Clemm spent their honeymoon. Rambaut was a miller and entrepreneur involved in many ventures around town. Here he boasts about the quality of his rooms and his stables. As a postscript, he mentions La Grange, Lafayette's estate, and pleads for visitors to pay their bills.

status were also reflected in his normal energetic personality was never noted by anyone. He may have become severely depressed by the ups and downs.

In April 1826, the French government appointed the Indemnity Commission to deal with the *ancien colons'* claims seeking remuneration for their property losses during San Domingo's slave insurrections. In October of that year, Rambaut wrote his will:

> *In the name of God Amen,*
> *I, Richard Rambaut of the Town of Petersburg, State of Virginia, being in proper memory make this my last Will and Testament as follows:*
> *Having some expectations of receiving something from the Government of France for my property in St. Domingo as per vouchers I forwarded on the 3rd of September last to Edward Gernon of Bordeaux.*

First: I give and bequeath to my wife Elizabeth Warren Rambaut, and to my son Gilbert Rambaut the whole of the Net Proceeds accruing from my said Claim, to be Equally difided between my said Wife & Son and for them to have the sole control of the same and to dispose of it as they shall think proper.

By this point, Rambaut could see the end. On January 1, 1827, the commission made restitution for just ninety-four of the fifteen thousand claims filed.

Ten days later, he wrote a lengthy letter to his wife, stating that "owing to my pecuniary embarrassments" he had decided to take his own life. While the full letter is nowhere to be found today, Rambaut did indeed commit suicide on January 12, 1827. He was sixty-four years old.

Rambaut's death was the talk of Petersburg for some time. Just days afterward, Mildred Campbell relayed what little she knew in a letter to her husband, Charles: "Poor old Rambaut put an end to his life last week by taking prussic acid. Mrs. Hammond told me she went over to see him soon after he had taken it—he seemed quite in his senses...Poor old man— some say he was an atheist but in his letter he mentions something about appearing before his supreme God. It think it probable he was a catholic." Mrs. Hammond, who claimed she saw Rambaut before he died, would later witness the wedding of her daughter and Rambaut's son Gilbert (see page 85).

Prussic acid is the antiquated name for hydrogen cyanide. It would have been readily available in Rambaut's restorative within his hotel. Today, some psychics visiting 12 West Bank Street claim that Rambaut still paces the second floor in front of the fireplace, making the ultimate decision about taking his own life. Nine years after his suicide, Edgar Allan Poe and Virginia Clemm, if they possessed any psychic powers at all, may well have sensed his presence.

For a short while after his death, the countess tried to maintain Rambaut's hotel. For a year, the lower-level space was taken over by Caldwell, a cabinetmaker. In 1829, Hiram Haines moved in and created his now famous Coffee House. The countess lived on until 1847, wearing black and remembering the handsome man who had helped her create a new life in a new land.

In a letter from Marshall Street written in 1892, Marie Morrison, a descendant of the countess, wrote:

The Untold Story of the Raven in the Cockade City

How well I remember her! Always dressed in black silk or satin, thin-soled high heeled slippers, her delicate old hands nearly covered with old, old rings and surrounded by ruffles of rare old lace, she sat and did nothing but make tarlatan flowers, a fancy work she learned in the convent in Parish, or hemstitched strips of fine thread cambric—she looked as if she stepped out of a rare old cabinet picture...

Ah, a like adversity seemed to have followed all things pertaining to the hapless family of de La Roche. I remember how much care my father always took of an old green box or chest bearing the arms La Rochefoucauld and La Roche on its silver escutcheon. This contained the relic of our past glories.

Alas, it was shelled all to pieces during our late war. It was placed in the basement of my father's residence on Henry Street in this city during the siege for safekeeping while my father and his family took refuge in Carolina. A shell struck the lower wall of the house, entering the basement just where this precious box stood, destroyed that and everything in its course. So much for earthly distinctions.

The Crown of France itself was no more, drowned in a sea of human gore—its hapless representatives made the jest and scoff of a raging populace—"that canaille," as I have so often heard my grandmother exclaim.

CHAPTER 5

FRIENDS AND POETRY LOVERS

While Richard Rambaut was running his flour mills and hotel, importing goods on the *Betsey* and touting his medicines in a booming industrial town, a poetic, ambitious young man arrived on the scene, looking for the kind of opportunities that attracted every young man to Petersburg. His name was Hiram Haines.

Haines was born in Delamore Forest, Culpeper County, in Northern Virginia, on November 29, 1802, and was, by his own definition, "trained to follow the plough." He received no formal education after the age of fourteen. No one is certain when he ventured south into Petersburg for good, but by the early 1820s, he was likely serving as a printer's apprentice or journeyman news reporter and was beginning to gain a reputation in town as a young man with literary aspirations and a gift for writing poetry.

At the age of eighteen, Haines began putting together a private notebook that proved his early interest in not only poetry but family history as well. The neatly handwritten book, now buried within the Haines family archives at Duke University in North Carolina, opens to a neatly written frontispiece dated November 29, 1820. It reads: "Original Manuscript Prose & Poetry by Hiram Haines, AET.AT AT 18."

On the next page, his preface begins: "Readers, These are the labours of they friend in the days of his youth, ere the mid-day sun of manhood had shed on him the rays of substantial reason; forgive his errors, for only those who forgive can expect to be forgiven."

This inscription marked the beginning of Haines' career as a fervent writer, editor and poet. He didn't know it, but at the time his muse, his lifelong raison d'être, was in Richmond spending a considerable amount of time with her favorite neighbor and playmate, Edgar Allan Poe.

The story behind Poe's honeymoon relates directly to the love story shared by Hiram Haines and the woman he ultimately married in 1826, Mary Ann Currie Philpotts Haines. In recent years, the friendship between Hiram and Edgar Poe has received attention, but few people know that Hiram's wife, Mary, was responsible for the initial Poe connection. Mary was the only daughter of Oakley Philpotts, a leading merchant and shipowner engaged in the London and Richmond import/export trade, much like Poe's foster father, John Allan. Mary's ancestors, like Hiram's, had emigrated from England in the 1600s. As a child, her family lived near the Allan home on the west side of Fourteenth Street in Richmond. She and "Eddy" often played together. According to Haines descendant Kate J. Haines, the two looked very much alike and were often mistaken for brother and sister. When Poe moved to Richmond years later to serve as the editor of the *Southern Literary Messenger*, their friendship was renewed. Edgar, as a fellow poet and editor, soon became close friends with Mary's husband, Hiram, and they not only visited each other frequently but also conducted a considerable written correspondence, much of which remains to be rediscovered.

The serendipitous nature of the relationship between Poe and Haines began in 1824, two years before Haines married Edgar's young friend Mary and five years before the two men actually met. As noted in earlier chapters, the Marquis de Lafayette visited the United States in 1824 at the invitation of the U.S. Congress. Lafayette, at age sixty-seven, traveled the East Coast to New York, Philadelphia, Washington, D.C.—pretty much wherever he wanted to go—celebrating at each stop the gratitude of a young nation as well as the best food, drink and accommodations each city could offer.

In late October 1824, Lafayette visited Richmond, Virginia. He toured the city led by a group of local boys known as the Junior Morgan Riflemen, a volunteer group that Lafayette had preselected to serve as his honor guard. Among its members was fifteen-year-old "lieutenant" Edgar Allan Poe. He and one other boy escorted Lafayette to John Marshall's pew in the city's Monumental Church.

There was already a strong connection to the Poe name for Lafayette. Edgar's grandfather, David Poe Sr., had established a reputation as a Patriot during the American Revolution. He enlisted in the army in 1778 and quickly advanced to the rank of major, receiving a commission as assistant deputy

One of several portraits of the Marquis de Lafayette painted during his 1824 visit to the United States. The artist in this instance was Samuel B. Morse, a prominent portrait painter of the time, who is best remembered for the telegraph he invented years later.

quartermaster general for Baltimore. When money promised by the Maryland government for supplies for the troops failed to materialize, David Sr. used his own funds to pay for them. In 1782, his responsibilities included transporting French troops that had come to aid the American cause. In the years that followed the Revolution, David Sr. was beloved by the citizens of Baltimore, who enjoyed calling him "General" Poe.

Just weeks before visiting Richmond and encountering young Edgar, Lafayette was seeking out Poe's grandfather in Baltimore. At one of the nightly balls, he was noted to say:

I have not seen among these my friendly and patriotic community, Mr. David Poe, who resided in Baltimore when I was here, and out of his own very limited means supplied me with five hundred dollars to aid in clothing my troops, and whose wife, with her own hands, cut five hundred pairs of pantaloons, and superintended the making of them for the use of my men.

Upon hearing that General Poe had died in 1816, Lafayette visited Mrs. Poe and then visited his old friend's grave.

The Lafayette-Poe connection illustrates the minimal degrees of separation between people of the time—something our history courses often neglect. Many familiar names of the eighteenth century were still around in the antebellum era, and many were in Virginia. While the founding fathers' generation and Edgar Allan Poe's era seem worlds apart, Poe did, in fact,

interact with the legendary Lafayette and, even more incredulously, with Thomas Jefferson himself at the University of Virginia.

The seemingly fortuitous nature of these events continued when Lafayette next visited Peterburg. He would be the common link that joined Poe and a future close friend and supporter years before they would meet in person.

On the afternoon of October 29, 1824, Lafayette entered Petersburg, the town that he had helped defend against the British during the Revolutionary War. The first stop was Niblos Tavern, which was located on Bollingbrook Street, on the southern side of the present-day Martin Luther King Bridge. With as large an audience as the town had seen to date, Petersburg mayor Lewis Mabry read some obligatory welcoming remarks. The Petersburg correspondent for the *Richmond Enquirer* covered the visit every step of the way:

> *Never have we witnessed so large and so well-conducted a procession, as that which welcomed LaFayette to our town; nor did we think it possible, such a one could have been paraded in Petersburg: It consisted of the Troop of Cavalry; Capt. Pegram (by whom the Gen. was escorted from the Ferry near Osborne's) then followed the "Guest of the Nation," in a barouche obtained for the purpose, to which succeeded a long line of carriages, containing his son and suite, navy officers, &c.—These were followed by the officers of the 39th and other regiments on horseback, the Independent Volunteers, Republican Light Infantry, LaFayette Juniors, citizens on foot and citizens on horseback.*

Once shown his quarters, Lafayette waved to the crowds on Bollingbrook Street from his window and then returned outside to meet some of the citizens. Certainly there were numerous Revolutionary War veterans in attendance, as well as the substantial French-speaking émigrés who had by now established themselves solidly in Petersburg society. While there are no records of the individual conversations, it seems almost certain that the general would have spoken with Richard Rambaut and his wife, the Countess de la Rochefoucauld, who would have had many remembrances of the ancient regime to share.

Afterward, Niblos provided a huge banquet. Seated at Lafayette's table were Lewis Mabry, Jabez Smith, Robert Bolling, Richard Field and Daniel C. Butts. The wine flowed freely as thirteen toasts were offered up to salute the Frenchman.

Some accounts say that William Niblos, son of John the tavern owner and entrepreneur, recited a poem of welcome written for the occasion by

the twenty-two-year-old local poet Hiram Haines. (Other accounts say Petersburg mayor Lewis Mabry read the poem.) Either way, Hiram Haines' tribute was heard by all:

"Lafayette's Welcome to Petersburg"

Hail to the Chief! who so bravely defended
Liberty's cause with his fortune and blade;
Hail to the Chief! whose Blood has been blended

With the soul where the foes of our country laid;
Long shall this tale be told,
Bright has it been enroll'd
Entwin'd and enwreath'd around his blest Name;
In the hearts of the Free,
Deep shall it ever be,
And with Time alone—fade his glory and Fame!

Hail to the Chief! in the midst of whose glory,
We welcome again on Columbia's short,
His name shall be bright on the pages of story,
When tyrants and despots are heard of no more;
Long may the Hero live
Long life may Heaven give,
And grant that he share what his braver won;
For in life should he be,
In the Land of the Free
And in death should he sleep by lov'd Washington

This event had to be one of the highlights of Hiram Haines' life. While in time he would meet presidents, congressmen and Edgar Poe, having his words read aloud to General Lafayette initiated his reputation as a poet of rank, at least locally.

When recounting Lafayette's grueling schedule of fêtes and celebrations, one has to emerge with an appreciation for his physical stamina. Most of Petersburg was likely hungover on Saturday, October 30, but they still managed to parade to Poplar Lawn, where roughly four hundred children from the Anderson School gathered to pay tribute to the general once again. Lafayette arrived at 11:00 a.m., and a Mr. Disosway—secretary for the

American Society for Colonizing the Free People of Colour of the United States—introduced the children.

One of the schoolgirls named Ellen recited a poem written for the occasion. Hiram Haines may well have prepared it as well, being one of the few if not the only resident capable of composing rhymes under short notice:

> Behold, love'd Chief, a youthful band,
> Attends with heartfelt pride on thee;
> Each glowing tongue and outstretch'd hand
> Here bids you welcome 'mongst the free:
> To you, Fayette, in part we owe,
> The Boon for which our prayers ascend,
> To Him, whose goodness will bestow
> Rich blessings on our country's Friend
>
> No laurel wreaths or tinsel'd crests,
> We bring, around thy boughs to twine;
> But warmly beating in our breasts,
> We give our hearts—for they are thine;
> Our proudest thought is that we're Free,
> And grateful to thy youth drawn blade,
> Within our hearts—is wove for thee
> A Wreath—that—Time shall never fade!

Lafayette's visit made a lasting impact on the town. But perhaps the most important offshoot was born of the need to rapidly prepare for visits of such important dignitaries. Shortly before the general's arrival, local mechanics and manufacturers met in the carpentry workshops of M.D. L'Anson and made plans to construct an arch to honor Lafayette. The general's plans brought him to Petersburg before the arch could be completed, however. The group decided that if local mechanics and craftsmen were ever going to get similar projects done on time, they needed to organize. They reconvened on January 4, 1825, at Richard Hannon's Tavern on Bank Street to form the Petersburg Benevolent Mechanics Association (PBMA). Despite what the term "mechanics" implies today, the group included a wide range of occupations and strove for "a closer union, for mental improvement, for the promotion of mechanical arts and sciences and for benevolent and charitable purposes."

The title page from Hiram Haines' book of poetry published in 1825. Haines was proud of his Masonic affiliation with a Northern Virginia lodge, as well as the many trade groups of which he was a member.

The following year, Hiram Haines, who himself was a member of the PBMA, published his first and only book of poetry, *Mountain Buds and Blossoms, Wove in a Rustic Garland*. It was signed by "The Stranger," a pseudonym that Haines used throughout his life when publishing some of his own poetry in the *American Constellation*, as well as in unpublished works. Haines identified himself through his Masonic affiliation by adding: "of Fairfax Lodge, no, 43, Fairfax chapter, no. 13, and Petersburg Council of royal and select masters, no. 5…Petersburg, Yancey & Burton, printers, 1825." Haines was clearly a member of a Masonic Lodge and other associations and proud of it. The lodge was located in his home territory of Northern Virginia and noted in much of his writing and artwork as part of his signature.

Mountain Buds and Blossoms, few copies of which are still in existence, was financed by subscription, or pre-selling, which was common practice at the time. Some buyers signed up for ten or twelve copies for resale or to serve as gifts. The volume's list of subscribers not only tells us the people that Haines knew around town but also provides a veritable who's who of antebellum Petersburg. Many of the subscribers were ancestors of people living in modern-day Petersburg. Some were the parents of Civil War heroes and industrial magnates who emerged later in the century. Most, if not all, of them would have visited Rambaut's Coffee House at the time or Hiram Haines' establishment five years later. Many were young men who were walking the streets, visiting Haines' Coffee House or generally milling around town during the times of Poe's visits twelve years later.

The subscribers include some of the town's most influential thinkers, as well as Haines' friends and business associates mentioned by name in his personal letters. Included in the list are:

WILLIAM ATKINSON: Grandson of one of Virginia's most important pre-Revolutionary Royalist tobacco merchants.

THOMAS BRANCH JR.: Merchant, auctioneer and banker who, years later, as a Unionist, reluctantly cast his vote for secession.

JOSEPH CALDWELL: A theater impresario involved in the construction of the large Bollingbrook Theater in 1818. He later built his own home that in time came to be known as the legendary Cameron Castle.

SAMUEL COLDWELL: A carriage maker who occupied Haines' Coffee House space for one year (1828).

ROBERT COLLIER: A lawyer who later became a Virginia senator and Confederate congressman.

JAMES S. FOLEY: An Irish immigrant, bricklayer and contractor who became a real estate developer and entrepreneur.

BENJAMIN FRANCISCO: Young son of Peter Francisco, hero of the American Revolution. When Lafayette visited Petersburg, he led off the ball by dancing with two of Benjamin's daughters.

RICHARD FURT: Richard Rambaut's partner in a local flour mill.

WILLIAM JOHNSON: Famous turf man and owner of some of the greatest thoroughbred horses in the country. Conducted racing business for the Newmarket track in a building on Bank Street that still stands.

WILLIAM MCFARLAND: Attorney of statewide prominence.

ALEXANDER GRAHAM MCILWAINE: Important import-export merchant who owned what is now still known as the McIlwaine House, moved from its original site to Old Towne's Market Square.

WILLIAM C. MOORE: Member of a family of prominent import-exporters who constructed Spring Hill and the house from which the Petersburg Room at the Metropolitan Museum of Art in New York City was taken.

SAMUEL MORDECAI: Son of Jacob Mordecai and Judith Myers, daughter of the well-known Samuel Myers of Richmond, Petersburg and Norfolk.

CHARLES F. OSBORNE: Cashier for one of the town's major banks. In 1839, he became president of the Petersburg Railroad, the third in the country and the first to run between states. Haines and Poe would have both been intensely interested in railroads at this time, when Petersburg was on the cutting edge of the new rail lines beginning to emerge.

SAMUEL PANNILL: Commission merchant and auctioneer.

EDWARD PESCUD: Publisher and editor of the *Petersburg Republican* and a regular habitué of Rambaut's Coffee House. He married one of Peter Francisco's daughters.

JOHN POLLARD: Successful saddle maker.

BENJAMIN HOLT RICE: Reverend who established Presbyterianism in Petersburg in 1823, often preaching in a large warehouse that sat where the current Siege Museum is located, across the street from Hiram Haines' Coffee House.

ROBERT RITCHIE: Petersburg lawyer who owned a large library and was likely involved with the publication of several Petersburg papers.

EDMUND RUFFIN: An agriculturalist, writer and political activist who founded several farming magazines and emerged at the forefront of southern nationalism after the death of his friend John C. Calhoun in 1850. As the Civil War approached, he went to Charleston to serve in the army at age seventy-four. He was added to South Carolina's Palmetto Guards and is believed, by some, to have fired the first shot at Fort Sumter.

WILLIAM S. SIMPSON: An immigrant from England who lived in Dodson's Tavern on High Street. Simpson was an artist associated with fellow painter William Murray Robinson. He was the son of Dr. Thomas Robinson, whom Poe called the most brilliant conversationalist he had ever met. Petersburg museums hold many of his paintings on loan from Preservation Virginia.

JONATHAN SMITH: Librarian and schoolmaster for the Petersburg Benevolent Mechanics.

JOSEPH C. SWAN: Prosperous Irish bookseller. His store moved around but was often on Bank Street, near Haines' Coffee House.

The dedication page to Hiram Haines' 1825 book of poetry. He signed and numbered each copy and paid for the printing by selling subscriptions. Haines was proud of his Culpeper County beginnings and mentions them here.

There were many more subscribers to Haines' book of poetry, though the names of some of the city's richest merchants, those who could most easily afford a copy whether they wanted it or not, are curiously absent. One can only speculate about who didn't subscribe. Suffice it to say that by and large, the people who did purchase Haines' volume would most likely have visited his Coffee House regularly or more easily conversed with the young editor Edgar Allan Poe. If some of the tobacco or flour merchants were anything like Poe's foster father, John Allan, they would hardly have had the time for such idle pursuits as publishing unprofitable volumes of poetry.

From the critical standpoint, Haines' little volume was well received and stood the test of time. One early twentieth-century critic saw hints of Robert Burns in some of the poet's "quaint mannerisms" and added that the primary importance of *Mountain Buds and Blossoms* lay in the fact that it was the first attempt "to celebrate adequately in verse the glories of Virginia."

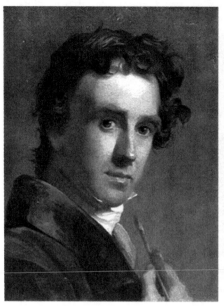 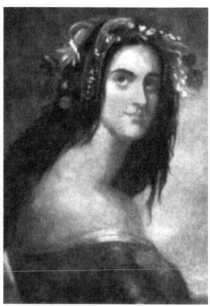

Above, left: Self-portrait of the artist Thomas Sully, who was born in England but, after immigrating to the United States, spent time with his family of fellow painters in Petersburg and Richmond.

Above, right: Thomas Sully, whose family of artists and actors had strong Petersburg ties, painted many portraits of the legendary Pocahontas. The lure of her tale influenced many eighteenth- and nineteenth-century Virginia writers and artists, including Hiram Haines.

The only public notice about the book was an advertisement by Haines himself as "The Stranger" in the *Petersburg Morning Advertiser* of August 2, 1825, announcing the book's availability "after a long and painful delay," attributed to increased costs occurring during production.

The predominant piece in the volume is a thirty-seven-page opus called "The Virginiad," in which an Indian maiden serenades the full moon and her lover. Haines, like others of the time, was clearly influenced by the popularity of the story of John Smith and Pocahontas:

> *I love thee, sweet orb, in thy beauty now beaming. Mild emblem of peace and queen of the night: Upon my warm bosom thy calm looks are gleaming. But ah! Thy view not my bosom's delight: Oh! Not like that course is its love ever ranging. As vestal's fire pure, so burns its first flame. Nor yet as thy face, will it ever be changing. A hundred new moons shall find it the same.*

The Untold Story of the Raven in the Cockade City

*I love the white warrior from over the water. He's brave in the fight
and kind to his foe; and the heart that is these will slight not the daughter
of the red chieftain who bears the strong bow; The necklace he gave me
is the color of heaven, our priests oft tell us that all there is love; And
sure 'tis now wrong, when the power is given. That earth should be like
the regions above.*

*I'll weave for my love a gay wampum belt shining with bright coral
shells, so lovely and fair; And I'll bind him a crest together entwining the
pelican's plumage with my waving hair. Oh! Then to him quick I smiling
will bear them, on his brow and arms my hands shall them braid; That
when he's away the fair warrior may wear them, And look and remember
his dark Indian maid.*

After the publication of his book, Haines' local popularity and reputation
as a romantic poet were well established. Many of his poems, however, were
written purely for the eyes of his beloved Mary before he would have the
opportunity to publish them in the *Constellation*. Among the family papers,
one poem was scribed on beautiful embossed paper and was apparently
written for his wife as a gift. A dedication on the top of the page reads, "To
M.A.C.P. of P. Va" (Mary Ann Currie Philpotts of Petersburg, Virginia). The
title is "The Lover's Adieu!" with the poetic instruction: "Air. Row Gently
here, my gondolier." The poem itself reads as follows:

*The blushing light—of morning bright
Has spread abroad its glow;
I must away—though love says stay,
Stern duty bids me go
O, could nought part those bound by love,
Save death's last sad decree
We should ne'er dream of heav'n above,
This earth so blest would be!*

*II
When once love's dart has pierced the heart,
And left its impress there;
No time nor place can e'er efface,
Or veil the sacred scar
O, those who can forget a wound,
Which gives such balmy bliss*

In colder climes—alone are found,
They could not breathe in this!

III
Then cease to sigh—dry, dry thine eye,
Fear not, I will be true;
Hope has relief—for all the grief,
Fate brings with this adieu:
O, how could we life's pleasures know,
If 'twere not for life's pain;
In bliss will be forgot all woe,
When we, love, meet again!
 The Stranger

Despite young Hiram's reputation as a poet, writing wasn't much more profitable in the 1820s and '30s than it is today. While Haines did work at and establish several papers, the period from 1824 to 1829 is still cloaked in mystery regarding his occupation. Beginning in 1829, he operated Merchants' Coffee House and the hotel above. But much of who he was, how he thought and what he was chronically in need of can be gleaned from the letters written to his wife as he traveled through North Carolina and Virginia.

Haines' letters to Mary, from 1825 to 1838, while limited, do provide insights as to his lines of work. Prior to 1834, when he began publishing the *American Constellation* with W.H. Davis, Haines worked as an itinerant collection agent for several of the merchant houses and tobacco magnates in Petersburg. Writing home to Mary, he recounts several long trips by coach or horseback through forests and over mountains, trying to collect money. Local historians believe that Haines was traveling to collect on behalf of Petersburg's major tobacco merchants, James and John Dunlop, as well as other wealthy clients. Hiring someone to go out and collect on past-due amounts for shipments of product or services was common practice at the time, and the Dunlops' office was situated at what is now No. 16 West Bank Street, the ground floor of what Hiram Haines would later call home. Always in need of money, young Hiram may have welcomed the opportunity to see other parts of the region while working for a company that was held in high esteem. This theory makes sense, but it was certainly not a full-time profession. Hiram Haines was born to be an editor, writer and poet, like his friend Edgar Poe, and he would in time find a way to

The Untold Story of the Raven in the Cockade City

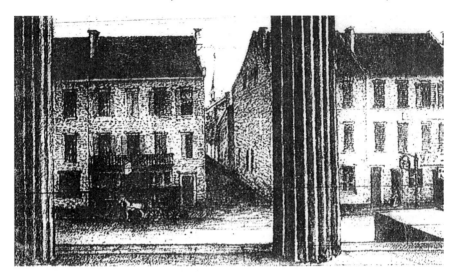

This drawing from the 1850s was done from the steps of what is now the Siege Museum, across the street from Hiram Haines' Coffee House. The horse and carriage are parked in front of what was Haines' residence. A fire in the late 1800s destroyed the top floor and brought about a widening of the alley. Curiously, no images exist showing Haines' Coffee House at the time. But these houses were virtual duplicates of each other, so we are likely looking at a mirror image of what existed on the other side, behind the column.

By the 1880s, the building that hosted Poe's honeymoon had become a bakery. A second structure in the rear housed brick ovens, the ruins of which are present today. Somewhat ironically, some thirty years after the honeymoon, the Sons of Temperance operated out of the second-floor honeymoon suite.

pursue these arts full time, even as money problems continued to plague him. From the road, he was still able to contribute poetry and news reports to his friends at the local newspaper, the *Petersburg Intelligencer*.

Haines opened his Coffee House at what is now No. 12 West Bank Street in 1829. The building, still under English ownership, was leased.

If it were only the two of them, it would have been natural for Hiram and Mary to live upstairs while operating the business on the street level. Richard Hannon and John Baird had designed the building with that purpose in mind and with an eye for luxury and style for upscale owners/occupants. Upper-level rooms on the third floor could be rented to boarders for additional income. But Haines, by the early 1830s, was parenting a growing family. His four children included a son and two daughters under five and a newborn, as well as his mother-in-law, so he needed a lot more room and a little less luxury than the second floor of No. 12 provided. A convenient solution sat right next door. What is now No. 16 is listed on the record books as Haines' "manse," or simply Hiram Haines' house. This building, an attached duplicate of the adjacent building housing the Coffee House, provided an entire house for the family, plus a yard for raising chickens and other animals. The offices of James and John Dunlop of London and Petersburg likely occupied the street level, and it may have been used for Haines' printing business as well. The brick façades original to the buildings offered little more than central entry doors with windows on either side. As in the case of most of Petersburg's retail spaces, more expansive storefronts with heavy overhangs and picture windows were the result of Victorian remodeling. While the upper level of what was Haines' house was destroyed in a late nineteenth-century fire and the building was narrowed in the process to widen an adjacent alley, remnants of the Haines family's stay remain to this day, including original fireplace hearths and wallpaper dating to the period.

Known as either Hiram Haines' Coffee House or Merchants' Coffee House, Haines' establishment next door to his home was but one of many offering food, drink and lodging. But Haines' place had the added plus of his personal collection of books, numbering more than two hundred volumes. While the terms "eating house," "restorative" and "ordinary" were used to describe inns and taverns in Virginia and elsewhere, "tavern" and "coffeehouse" were used in Petersburg. But they were still places where one could restore the body and the soul. Merchants' Coffee House became a popular hangout for politicians, intellectuals and writers to gather in the 1830s. It provided a place to eat, drink, talk and argue. Plus, it offered the

intellect and creative energy of its owner, as well as the gracious hospitality rendered by Mrs. Haines.

There is no evidence that Haines was printing anything before May 24, 1834, when he and W.H. Davis began publishing the *American Constellation*, with offices on Old Street. The façade bore the slogan "For the Union—For the People." In addition to publishing the newspaper, the partners solicited work publishing books, pamphlets and flyers. In December of that same year, the business moved to a location on Sycamore Street, behind J.C. Swan's bookstore. Haines' partner is thought to have been the same Davis associated with the *Richmond Compiler* in 1835 and for many years thereafter and then the *Richmond Dispatch*.

After 1835, Haines published the *Constellation* on his own and was doing so when Edgar Allan Poe and Virginia Clemm visited for their honeymoon. Haines was admitted to the Petersburg Benevolent Mechanic Association as a printer in 1835.

It is not known exactly when Haines' wife, Mary, and Edgar Allan Poe renewed their childhood friendship. It is very likely that Poe had few memories of his childhood friend and met Hiram Haines as a prominent fellow editor in the interest of promoting the *Southern Literary Messenger*. Learning that Haines had married his childhood playmate may well have proven a happy coincidence.

Haines was known to be a politically active Mason—intelligent, generous, poetic and well liked by the people of Petersburg. Little Mary, from a wealthy Richmond household, had found herself a good and literate man from considerably humble beginnings. Haines and Poe immediately found that they could help each other professionally. The *Constellation*, under Haines, published reprints and reviews of pieces written by Poe, as well as extracts of editorials written in the *Southern Literary Messenger*. Poe, in turn, did all he could to promote the *Constellation*, which at the time was one of the leading Democratic papers on the East Coast.

Haines published much of his poetry in the *Constellation* by "The Stranger." And he may have left one that remains a bit of a mystery. Inscribed in stone on one of the walls of the old Blandford Church in Petersburg are these words:

> *Thou are crumbling to the dust, old pile*
> *Thou are hastening to thy fall;*
> *And 'round thee in thy loneliness*
> *Clings the ivy to thy wall*

The worshippers are scattered now
Who knelt before thy shrine,
And silence reigns where anthems rose
In days of "Auld Lang Syne."
And sadly sighs the wandering wind,
Where oft in years gone by,
Prayer rose from many hearts to Him,
The Highest of the High.
The tramp of many a busy foot
That sought thy aisles is o'er,
And many a weary heart around
Is still forever more.

How doth ambition's hope take wing!
How droops the spirit now!
We hear the distant city's din;
The dead are mute below.
The sun that shone upon their paths
Now gilds their lonely graves,
The zephyr which once fanned their brows
The grass above them waves.

Oh! could we call the many back
Who've gathered here in vain.
Who've careless roved where we do now,
Who'll never meet again;
How would our very hearts be stirred
To meet the earnest gaze
Of the lovely and the beautiful—
The lights of other days!

For many years, authorship of this poem has puzzled historians. Some attributed it to the visiting actor Tyrone Power, the eighteenth-century ancestor of the popular Hollywood leading man bearing the same name. Many others have claimed that it could only be the work of Hiram Haines. In the late 1870s, the topic came to light in the newspapers of Petersburg and Richmond (presumably on rather slow news days). One Richmond printer and publisher, Charles H. Wynne, who was by then deceased, had attributed the poem to Haines. Wynne stated that he himself was an

apprentice to Haines at the time that Tyrone Power visited Petersburg, but his old master, Hiram, wrote the poem while visiting the churchyard with a friend (Poe perhaps?). According to Wynne, Haines then published the poem in his own paper. However, a search of the few Haines-edited newspapers still available today does not reveal any evidence of the poem. And a copy of the poem was said to have been discovered in the church in 1841, after Haines had died in January of that year.

Merchant's Coffee House.

THIS Establishment will be found always supplied with every delicacy the market affords, the best wines, liquors &c. constantly on hand. The Books of the proprietor are posted, and he will thank those indebted to pay up, as the money is wanted. From his engagements, many bills due his establishment have been placed in the hands of a profession-al gentleman, and the same cause will neces-sarily oblige the proprietor to give all those that are unsettled on the 1st of January; the same dilemmas. Six years are long enough to let accounts stand open. —H. HAINES.
Nov. 25. 79--ts

Things began looking bad for Hiram Haines' coffee establishment by late 1836. For several weeks, he placed advertisements in the *Constellation* and elsewhere asking his customers to settle up their accounts.

While the poem seems to be a slight deviation in style from his other work, the fact that it was attributed to "The Stranger," Haines' well-known nom de plume, highly suggests that he was, in fact, the author.

Hiram Haines went from rural obscurity to urban popularity and influence at a time when the United States was growing rapidly, economically and intellectually. Yet hard facts, newspaper articles and even poetry can hardly offer the world of today a genuine feeling for what the people of the time were really like. Even letters can, at times, seem stilted or overwritten, particularly those written with the knowledge that a broad audience might read them. Haines' descendants have done us a great service by preserving his personal letters in the rare manuscripts room at Duke University's Rubenstein Library. They are the personal, intimate correspondence of a man often under duress, sustained by the love and devotion of the one to whom they were addressed, Mary Philpotts Haines. Though the language is often florid, the content seems as real today as when it was written more than 170 years ago.

CHAPTER 6

THE REAL HIRAM HAINES

Nothing makes history come to life as much as the very personal letters of an individual, famous or not. Hiram Haines' letters written to his fiancée, and later wife, Mary Ann Philpotts, are extraordinarily revealing because they are so personal. Written during his travels through North Carolina, Virginia and Washington, D.C., the language is such that, at times, the letters could very well have been written by a person living today. In letters mailed between 1825 and 1838, the reader not only witnesses a passionate love affair but also comes to empathize with the many hardships of the road. Young Hiram endured extremes of weather and terrain and often became ill from one malady or another. He encountered interesting people, from crusty veterans of the Revolutionary War to congressmen, senators and future secessionists. Above all, his humor and playful and often passionate love for Mary permeated the early letters. Later, as money problems persisted and the stresses of travel took their toll, a slight tone of world-weariness entered the correspondence. The letters are particularly fascinating not only because they bring an antebellum love affair to life in the twenty-first century but also because they are a glimpse into the period in which this unusual, curious and adventurous young man's line of work brought him in touch with some of the leading players of the day, including Edgar Allan Poe.

Interestingly, Haines' handwriting changed dramatically on occasion, with no apparent correlation to age, time of year or location. It is possible that some were written in a riding coach, while many were put down by candlelight. He often was ill, with colds or fevers, and this may have

Hiram Haines' self-portrait, long buried in the family archives at Duke University, was rediscovered by the author while researching this book. In this image, likely drawn around 1826, Haines depicts himself as the young dandy he likely was. The page is the second in his personal journal of his genealogy. His Masonic Lodge symbol and affiliation is proudly touted here, as in most of his written work. The inscription reads, "The Pen, At once the friend & Enemy of mankind. Some eyes to open & some to blind."

contributed to a shakier hand. On several occasions, he mentions having been "bled" to improve his health.

In May 1826, after a particularly hard day of travel, Haines wrote Mary from Halifax, North Carolina. Here, some insights into his romantic nature, his philosophic ruminations and, like Poe, perhaps his fondness for Byron are revealed:

> *I shall be detained here several days, beyond the time anticipated at first in consequence of some difficulty having arisen in the late moment of the business which brought me out. It is impossible for me to say, my Dear Mary, on what day I shall be at home. I will do all I can to get off as early as possible, and I long for the moment to arrive when these arms shall again enfold to my bosom, Her, whom I love so well—the dear being on whom rests all my fond hopes of happiness in this world—will it be sacrilege my dear Mary, to add in the next world too? Surely those whose hearts are united on Earth, will not be separated in Heaven—if they are, the place can be no heaven to them—it would be none to me. I am vastly fond of the paradise of the Turks, Mary. You are enough of a Mohamaten [sic] to know that according to their creed, the seats of endless bliss are peopled with beautiful women. Houris they call them, angelic creatures with fine large black eyes—sparklers, like those of my own dear Mary. The Elysium of the ancients pleases me much. Those evergreen and beautiful fields where the Spirits of the Great, the Virtuous, and the Good meet in the shapes and inspired by the feelings which they wore and cherished on this side the sullen waves of the dark, rolling Styx. There, those who have been friends on earth again meet, recognize and mingle with each other. They enjoy a pleasing remembrance of all the pleasures of which they had partook in of the world they have just left, as well as the superior bliss of the one which they are never to leave! The heaven of Christians seems to be the most unnatural of all to us poor carnal minded sinners.*
>
> *There must be something like a communion of souls even this side of the grave, Mary. In our dreams we see, we speak, or Mary, we feel each other as naturally as reality itself. Often have I fancied that I have clasped you in my arms and was watching a kiss, which you bestowed as reluctantly to my dreaming fancy as you often do to my waking reality—oh! you errant little witch you; just wait till I get home, I'll pay you for it. I'll tie your hands behind you and then if you don't bite off your lips, kiss them I will, while I have strength to imprint a kiss on them! You may "scream," say "quit it" and "don't" and "behave" or welcome, but it won't do, it won't do I tell you Mary, so just prepare yourself to yield to your fate as quietly as possible.*

The Untold Story of the Raven in the Cockade City

One of his longest, most detailed letters, dated July 4, 1826, presents a rare eyewitness account of a July Fourth celebration in Warrenton, North Carolina. At times, his description seems almost satirical, but by the end of the letter, one can assume that he was indeed sincere. It illustrates quite well, however, Hiram's skills as a storyteller and as Mary's personal humorist:

Warrenton, July 6ᵗʰ 1826

My Dear Mary Ann:

I promised in my letter of yesterday to devote the morning of Thursday to giving you a description of the celebration of the fourth in this place: I now attempt the task—rather I should say amusement for if it be a task it certainly is a very pleasing one since I flatter myself it will add to your gratification. Well then. The 4ᵗʰ of July 1826, like the same day of the same month for over six thousand years, dawned just at daybreak in the morning, the all important event was announced to the drowsy city of Warrenton but the discharge of their heaviest ordinances, namely a four pound iron cannon, whose astounding thunder did not reach the ears of the writer, who happened at that moment to be reposing fast locked in the arms—"What! What! What's that? Fast locked in whose arms! Ha? Why you impudent wretch if you were locked in anybody's arms how dare you have the assurance to tell me of it? Don't open your mouth to speak! Don't I say—I won't forgive you, you need not expect it! You can go Sir!"—Now wo! wo! wo! if you please my dear Mary, to let me tell my own story in my own way and then if you tell me "to go" why in the name of patience let me go in peace and not with such a din about my ears—well then the reason I did not hear the thunders of this aforementioned heavy piece of artillery was because I lay fast locked in the arms of Somnus or his son Morpheus I don't rightly remember which—I rather think however that it was the old gentleman God himself, for he is represented as being much the soundest sleeper and a ride of fifty mules the preceding day had put me in a fine humor for napping it. Well then the cannon was fired; (so I was informed) darkness, with sable countenance and sullen step retired to the west to hide himself in the gloomy caves of night, while which pealed in their ears could not nothing short of a blast from Gabriel's trump proclaim the end of time and beginning of eternity; or the roaring jar of an earthquake, by which they were to be entombed in the bowels of the earth!—not so the old fellows: they had heard the thunder of artillery before and conceiving this as a preface to a second edition of the battle of Guilford Court House disencumbered themselves of everything that could retard their flight and

seemed to be looking which way they most easily could escape from danger. On being assured, however, that the discharge was only in honor of the day, and the British soldiers whose glittering arms and showy uniforms they had caught a transient glimpse of on the field of Guildford, had to a man long slept in more honorable graves, then they would ever fill, these worthy veterans of the battle once more assumed their cheerfulness; the panic had struck too deep; and the dry joke and dryer laugh, the self pleased chuckle, and the tedious, dull, uninteresting story which before assured them—were heard no more!

The hour for assembling to hear read the Declaration of Independence and the oration prepared for the occasion arrived when a numerous and highly respectable audience collected; who could not but listen with interest and attention to the most important state paper ever penned and as neat, appropriate, and elegant harangue, as was produced, I venture to say, in any part of the United States on the occasion. After these ceremonies were over the crowd dispersed in various directions and the majority of that part already particularized resumed the interesting recreation severally mentioned until the hour of dinner—an hour long and ardently prayed for ere it came—not that by any means it was a late dinner, only a great many of the good people had not over-laden their stomachs with breakfast that they might the better be enabled to eat their dollars worth of a 4th of July banquet—and it was indeed a sumptuous, well ordered and well arranged one.

Beneath a spacious arbor was spread the board for the feast of freemen. The citizens of Warrenton with a liberality highly creditable to them, had through the Committee of Arrangement issued cards of invitation to all the surviving officers and soldiers of the Revolution in the county, who were requested to come forward and partake "without money and without price." About thirty of these "time honored" worthies, some limping, some hobbling on crutches from the glorious wounds they had received on the field of battle, others with visible scars and powder marks on their faces and hands, assembled at the table, a particular portion of which was reserved for their especial accommodation. Among them chatting with the most endearing familiarity, like a patriarch among patriarchs was the Venerable Nathaniel Macon, whose name I have mentioned on a former occasion, and with whom I was here so happy to form an acquaintance. For some*

* Nathaniel Macon was a senator and spokesman for the Old Republican faction of the Democratic-Republican Party, which Haines' newspapers later supported. Today, his name is all over the map, from Macon, Georgia, to Randolph-Macon College.

time I had a seat near them and listened as you may well imagine with the most interesting anxiety to their details of these old veterans about the battles, their skirmishes, marches, countermarches, trials and sufferings. Some of them had fought under Washington and it would have drawn tears from your eyes my dear Mary, as it did from those of your dear Hiram, to hear the terms of enthusiastic—of devoted affection on which they spoke of their illustrious commander. Every pallid cheek flush'd— every dim eye flash'd fire at the bare mention of the hero's name! One old man could not contain himself, so highly were his feelings excited— he had been one of Washington's body guards and though old was still straight as the pines of his native hills. Rough he was 'tis true. But it was that sturdy downright roughness in look and manner that marks sterling worth and unyielding courage. Some one present asked if he remembered Washington—"Remember him! (said he raising his person and his voice) Remember Washington! Why yes God help the old jinneral! I served the whole of the Revolutionary War from beginning to ending—I was in eight jinneral's engagements!—see here, I lost an eye in one—two fingers in another—look at my bald head! Remember jinneral Washington! I fit by him at Monmouth—I fit by him at Jarmantown—I fit by him at Brandywine—I fit by him at Little York and if he was alive I'd fight by him still! But he's dead God bless him! I knows he's gone to heaven—" Here the tears gushed from his solitary eye and flowed in thick profusion down the deep funnels of his dark sunburnt cheeks—his lofty person seemed involuntarily raised to an attitude of the most terrific majesty—his right arm extended and the mutilated finger of his hand clenched, while he rolled up the sleeves of his dress with the left—and continued—"but if there's one man here—if there's one on the fact of the yeth, that says anything against the jinneral—that I am old, yet let him speak and I'll smash him down as I smash this table"—and his fist descended with a force that shivered to atoms the plate on which it fell, as well as a part of the temporary table beneath it! This man's name was George Tapp—it is worth remembering.

Shortly after this a special deputation waited on me from Col. Jones, President of the Day, to take a seat immediately on his right. Though highly delighted with my situation among the Revolutionaries, I could not with propriety accept an invitation, so highly complimentary as well as unexpected, so I resigned my station of heartfelt pleasures, for one of empty honor, where however the most marked attentions that could be paid to a stranger were tendered me on all hands.

A great many toasts were drank, a list of which I will send you with my next letter. The president toasted our great fellow citizen Mr. Randolph, in return for which I gave when called on by him for a toast—one complimentary to North Carolina. Every thing was conducted with and concluded with the most pleasing and perfect harmony…By sundown, everything was still and orderly; [indecipherable], fly catchers, stone jerkers, marble players, smokers, lopers and dram drinkers having had all they could of the 4th of July in town were returning home each with his own wonderful tale of the important events of this important day. Now had Phoebus driven his chariot down the western sky, and the last flashes of his trains of light began to be observed by the unfolding curtains of darkness— at last they entirely vanished—not the least glimmering trace of day appeared and the 50th anniversary of American Independence had passed forever!

Unknown to Hiram Haines and the other celebrants, it was on this same day, July 4, 1826, that Thomas Jefferson and John Adams both died. Edgar Allan Poe was a student at the University of Virginia, which Jefferson presided over at the time. When Haines learned of Jefferson's death in the days that followed, he quickly penned a poem of tribute as part of a letter to Mary, showing not only his patriotism but also his ability to rapidly write inspiring verse to suit an occasion:

The loftiest oak of the forest is low
Had fallen—to mingle with its parent mould:
Ten million warm hearts, shrouded in woe,
Proclaim that the noblest among them is cold!
Jefferson sleeps on the soil of his birth—
Full of honors of years. Freedom's Father has gone:
Unrivalled in fame—unequalled in worth,
On Earth like him left, there is none, there is none.

The greatest of all the Great is dead—
The philanthropist-patriot-sage is no more;
To God, the purest spirit has fled,
A loss to the world—a world's tears should deplore!
The length of his years—his toils for mankind,
Ceased on that epoch which had hallowed his name:
The luminous light of his deathless mind,
As endless will shine, as his eternal fame!

The Stranger

The Untold Story of the Raven in the Cockade City

Haines immediately forwarded the poem to "Mr. Yancey, who will, I suppose, give it a place in his Friday's paper." While Haines was not publishing a newspaper yet, he was clearly contributing to the hometown papers whenever he could. At the time, Yancey was the editor of the *Petersburg Intelligencer*.

Small bits of Haines' letters offer additional insight into the personality of the man and the milieu. On several occasions, for instance, he continues to suffer from an unknown sickness and stops by a local doctor's office to be "bled." Bleeding as a medical treatment went back to the ancient Greeks, who believed drawing blood from the body helped keep one's four humors (blood, phlegm, yellow bile and black bile) in balance. Bleeding methods ranged from cutting with a special bleeding device to the application of bloodsucking leeches. Another method, cupping, involved pressing a heated cup on the skin to create a vacuum. When pulled off, the covered area bled. We don't know which method Hiram Haines endured. Bleeding was well out of fashion by the mid-nineteenth century; doctors (or barbers) in rural North Carolina may have been among the last practitioners.

While we don't have any of Mary's letters to refer to, it is clear that she periodically tired of Hiram's travels, resulting in a number of long-distance spats. At one point in 1826, she apparently threatened to become a nun. Typically, he met her complaints with humor: "As to your becoming a nun, why if you wish it Mary, bundle up and put off to a convent as soon as you like, but may the Devil take me if I don't find a way into your cell if I have to bribe the old porter to let me down the chimney by a rope! You wouldn't want the smoke to drive me back, would you?"

Like many young men of the day, Haines admired Napoleon Bonaparte— the era's ultimate role model when it came to ambition, bold actions and industriousness. On one occasion in 1827, noting Mary's complaint that she had not received anticipated letters from him while expecting their first child, he wrote: "I can assure you my dear wife that however willing I may be to bear a portion of the burden of our young Buonaparte, that is to be (have I not done so already?) yet I have not since I left home been affective in the manner you mention." In another letter from North Carolina, he mentions having purchased a print of young Napoleon, suitable for framing.

On June 10, 1827, from Locust Grove, North Carolina, Haines wrote his wife as the day drew to a close, as he apparently did each day as long as there was time and a candle bright enough to see by. His humor and playfulness shines through the hard days of travel:

The marriage bond between Hiram Haines and Mary Ann Philpotts, whose last name is misspelled. They were married in August 1826, when John Tyler was governor of Virginia.

Although I date my letter Thursday morning, it is Wednesday night and my candle is near burnt to the socket, I must conclude—but stop, I have it… from recollection, a little jeu d'espirit which I met with in some of the North Carolina newspapers the other day…

To—
Minerva elected—come pray tell me true
What the woman would do, if man were not to woo?
 Answer—
You ask what women would do, were men not to woo?
I'll tell you, though to do it I blush red as rubies,
They'd go wooing themselves, & woo far better than you,
They'd take <u>no denial</u>—ye Boobies!
 I intended communicating this before and perhaps have done so, if I did
excuse the repetition and believe me my dear wife your affectionate husband.
H. Haines

It is unlikely that this unusual ditty appeared in local papers—Haines seems to have often injected satire or tongue-in-cheek remarks within his letters.

Another letter, also from Warrenton, includes a poem expressing how much, as always, he missed his Mary:

The Absent Lover's Song in Carolina.
 Air. Robin Adair.
 I
This land's no desert drear
Where savage yells,
All Heav'n has planted here,
In worth excels
Sweet is each scene around,
Beauty and wit abound,
Talent and taste are found,
Here friendship dwells.
Yet 'tis a wild to me,
Mary's not near
Bright, bright this clime would be
If she were here!
'Tis her who gives the rest
To all that makes one blest
O! Ill this heart can rest
 II
Though here's full many a face
Divinely fair,
And natures lavished grace

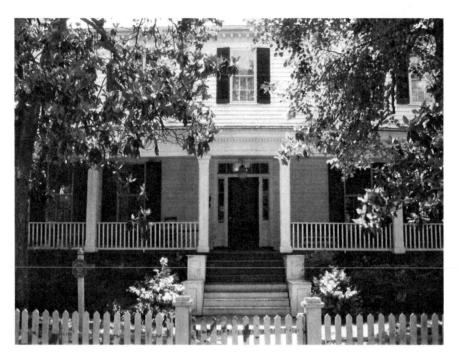

Built in the late eighteenth century, the Rambaut-Donnan House on Perry Street served as the setting for the 1833 wedding reception Hiram Haines described in a letter to his wife. Many of the town's most prominent citizens were in attendance. Three years later, Edgar Allan Poe was likely to have met many of them.

On shape and air;
Though rich their light locks flow,
Though sweet their ripe lips glow,
And pure as virgin snow
Each bosom fair;
Yet what, oh, say to me,
These beauties bright?
I gaze in vain to see
My heart's delight!
No ringlets like hers shine,
No looks beam so divine
No lips so sweet as wine
No heart so light
The Stranger

Clearly, while Hiram Haines may have lacked genius when compared to Poe, he certainly carried a poet's heart. And poems such as these, sent solely for the eyes of his wife, came from sheer inspiration, written in the field with rarely a scratch through to change a word. He was a patriot and a product of antebellum Virginia, so the superlatives are in fact reflections of his genuine sentiments.

THE RELUCTANT GUEST

One of Haines' most interesting letters presents a glimpse into Petersburg's social life at the time. On a rare occasion in 1833, when Mary was away in Washington, D.C., for unknown reasons, Hiram was free to hang out with his friends and attend, for the sake of social commitment, a wedding reception. He appeared fashionably late by about two hours but recounts at least some of what happened in a highly amusing manner.

The party was celebrating the marriage of Richard Rambaut's son, Captain G.V. Rambaut, to Jane Hammond, the daughter of Joel Leroy Hammond and his wife who was part of the Douglas clan in Scotland. Hammond, a well-to-do merchant, was originally from "Hammond's Mountain" in South Carolina and related to Senator James Henry Hammond. Among the guests or noticeable absentees Haines mentions are Sam Myers, whom Hiram calls his "other wife," a silversmith and close friend and part of the local Jewish community; and Dr. Maye, who lived on High Street near the Coffee House.

G.V. Rambaut, son of Richard Rambaut and the Countess Elise de Rouchefoucauld, was a tobacco merchant who was the first and only commander of the Petersburg Guards, a prominent military organization at the beginning of the Civil War. He entered the Confederate army as a captain of artillery, even though he was more than sixty years old at the time.

Poe may well have met many of the local people mentioned in Haines' letter during his regular visits or on his honeymoon just three years later. The Mrs. Rambaut referred to is, of course, Countess Elise. McIndoo, spelled McIdoo in the letter, was Charles McIndoo, an employee of the Dunlop tobacco firm and a son-in-law of Joel Hammond.

Hiram Haines seems reluctant to go to the wedding reception and delays things with a few drinks before walking to what later became G.V. Rambaut's house, which still exists today on Perry Street. His reference to his "Devil's Den" is a rare mention of his Coffee House:

On returning from Bat shooting at Roslin on Wednesday evening last, I found awaiting my arrival the following note: "Mr. & Mrs. Hammonds compliments to Mr. Haines and solicits the pleasure of his company at their house at ½ past 7 o'clock on Thursday evening." You and my other wife Sam Myers being out of town, I have renewed the courtship with my old friend Dr. M. Maye and we are so nearly married again that as in former times we divide a bottle of the best alternately at his office and my "Devil's Den" as the damned [indecipherable] call it. On the appointed evening we concluded to "Haste to the Wedding" together and made our entre at the fashionable hour of nine o'clock full, dressed from top to toe— the business—I mean the parson's part of it was of course over hours before and the balance I suppose was consummated in the course of the night. The company was not very large, the house only comfortably full—no squeezes: the bride looked as she always looked, the groom so & so. Mr. Hammond looked ecstatic!, the old captain as if he thought "all is well that ends well" and my friend McIdoo gave one a look and a squeeze of the hand which spoke as plainly as words 'as 'tis so, if it can't be as 'tissen, but I don't like it…it is very ungenteel For a lady to swear with her tongue so Mrs. ----- swore with her eyes. Mrs. Rambaut was there, but the Kendalls and Eliza were not. John Jeffrey has returned and sold his property—the B's are quiet, and the strumpet is going to marry Young the coachbuilder. She says now—I understand—that John is not the father of the child. What think you of that? Wonders will never cease!

On other occasions, when Haines was road-weary in North Carolina, his moods could be darker, as he felt the pangs of being away from home. After being delayed in Hillsborough for a day and having met with future North Carolina Supreme Court justice Thomas Ruffin, Haines realized that he would not likely be home in time for Mary's birthday, which fell on Christmas Day:

Every day's, indeed I may say every minute's absence heightened my solicitude to reach home; increased my anxiety to hear from, or to see the dear partner of my bosom; the sharer of my joys, the soother of my sorrows. But I fear, so many and so unexpected are the delays I meet with, that I shall not be able to get to Petersburg in time to take my Christmas dinner with, to greet you on your birthday…Should such be the case my dear wife, I pray you accept the heart-warm wishes of your Hiram for many, happy and pleasing returns of a day, the approach of which a world anticipated with joy, which a world

ushered in with praise and thanksgiving: I shall join in hailing it with no ordinary emotions, not only because on that day was born a saviour, to whom I look for happiness in a world to come, but because that day gave birth to an angel in mortal guise, who had already contributed, and who I trust in God will long be spared to add to my felicity this side of the grave! Yes! My dearest Mary. Heaven will not surely seek hearts interwoven like ours, 'til ripe old age had silvered o'er our heads, had made our bodies unfit for time, had prepared our immortal souls for eternity. Then may we sink gently to the grave! Hand in hand may we go! The same shroud, the same coffin, the same cold narrow house entomb our dust, that it might be said of us by the passing stranger who glanced at our tomb, "Their hearts, united by the tenderest ties in life, in death they were not divided!" Such be our fate, I pray heaven! This prayer, I know is re-echoed by yourself.

In the years 1836 through 1838, despite financial difficulties that forced him to close the Coffee House, Haines' reputation as the editor and publisher of a leading Democratic paper brought him in close contact with the high and mighty of the day. In June 1836, he visited Washington's home, Mount Vernon, and then went on to Washington, D.C., where he met many

One of the many ads Hiram Haines ran in the *American Constellation* promoting his Coffee House. With the Appomattox River just a few blocks away, finding turtles for his soup, at least at certain times of year, did not seem to be a problem. Coffee and spirits were always available as well.

TURTLE SOUP.

THIS DAY, and every day this week, at the
MERCHANT'S COFFEE HOUSE,
Bank Street

Soup ready at 11 o'clock.

Beer & Cider,

Fresh supplies received and on tap.

August 4. 31—ts

members of Congress, including Clay, Calhoun, Webster, Polk and others. As a publisher and journalist, he spent much of his time with the printers of the congressional reports, Clair and Rives.

One distinguished man who apparently offered much of his time was Congressman George C. Drumgoole. "General" Drumgoole represented Brunswick County, south of Petersburg. Like Haines, he was a Mason, master of Brunswick Lodge No. 52 and grand master of the state of Virginia. A year after Haines had met with him in Washington, Drumgoole found himself in the midst of a political argument over dinner with the owner of a Lawrenceville tavern, Daniel Dugger. Both men were very likely drunk, and Dugger slapped Drumgoole in the face. The insult could only be met with a challenge to a duel.

Hiram Haines was summoned to be Drumgoole's second a few weeks later. Rules were drawn up and the agreement stated that the duel was to be to the death. Hiram protested the use of deadly force, but his pleas went unheard. So he spent several weeks prior to the duel teaching Drumgoole how to use his weapon. Allegedly, Haines taught him how to maim his opponent without actually killing him.

According to Dugger family histories, the duelists and their assistants met on the North Carolina border. Hiram Haines was in the ballroom dress of the period—"lace ruffles at his bosom and on his hands, silk stockings and pumps." When the ritual was completed, Dugger lay on the ground mortally wounded. Haines allegedly stood in front of Drumgoole with his arms folded, intentionally blocking the general's view of his bloody, dying adversary.

The recollections of Dugger's ancestors provide more value insights into the personality of the man who hosted Poe:

> *Of Mr. Haines we know very little, and of his subsequent history nothing. He had formerly been the keeper of a coffee house in Petersburg. At the time of which we speak, he was the editor of the Democratic paper of that city. The position he filled towards Gen. Drumgoole, and his conduct in it, bespeaks the gentleman and a man of some political prominence. Throughout, he exhibited conduct and character. He has been described as a tall, fine looking man, with a military bearing. In this hostile meeting his deportment was rigidly polite and formal.*

By 1838, Hiram Haines found himself surprised with his own reputation as a newspaper editor and publisher, despite having had to close the Coffee House and place virtually everything he owned up for collateral to pay his debts. Writing from Washington, D.C., on June 9, 1838:

The Untold Story of the Raven in the Cockade City

The Rue Morgue room in the present-day Hiram Haines Coffee and Ale House functions in an alley that is now covered with a roof and skylights. The left wall is the back of the Bank Street building. The right wall is the front of a second building that began as a stable when the alley was open. After the Civil War, brick ovens were built inside as the business was transformed into a large bakery. *Photo by Jeffrey Kyle Rayner.*

My Dear Mary,
Yesterday and today have been a round of complete mental and personal gratification. Last evening I spent with the President and his family, and a social and select party. This evening I dine with Mr. Van Buren at 5 o'clock for which I am just dressed. I have a thousand things to tell you which I have no time to do at the moment...I am working my way smoothly and quietly, keeping perfectly on my guard in all respects and commanding that attention, which would turn away other brains than mine, as for the same circumstances. God bless you!
H. Haines

At this point, Haines was enjoying his last days with the *American Constellation* and the high point of the political influence he wielded as publisher of the South's most influential Democratic paper. While he would start other papers and continue to communicate with his friend Edgar Allan Poe, his days in publishing were beginning to draw to a close.

THE HONEYMOON

The life and work of Edgar Allan Poe have been written about in countless biographies, critical essays and prefaces to collections of his work. Yet, as stated at the outset, the people and places surrounding his marriage to Virginia Clemm and his honeymoon have been relegated to little more than footnotes.

POE'S LIFE IN BRIEF

While cut short at age forty, the life of Edgar Allan Poe was eventful and diverse by any standard. His personal story is replete with tragedy, romance and enormous introspection, creativity and the constant struggle to survive financially. To put the honeymoon period in perspective, a brief review of his life overall is helpful.

As recounted in chapter three, Poe was born in Boston in 1809 to the actors David and Eliza Poe. When his mother died just two years later, he was taken in by the Richmond merchant John Allan, who offered him excellent educational opportunities but little affection. He was never formally adopted. Poe spent the years 1815 to 1820 in London, where John Allan attempted, without success, to establish a branch of his import/export business. Attending the finest schools, Edgar mastered both Latin and French.

Back in Richmond, 1824 was an eventful year for Poe. In June, at age fifteen, he exhibited his considerable athleticism by swimming the James River against the current on a dare. In October, while a member of the Junior Morgan Riflemen, Poe met the Marquis de Lafayette during the Revolutionary War hero's visit to America. Poe's grandfather had provided the general with considerable assistance during the war.

In 1825, John Allan's uncle died and left Allan a considerable fortune, some $14 millions by today's standards. The family moved from a modest Richmond residence to the fabulous mansion Moldavia. Poe never benefited from his foster father's windfall.

He attended the University of Virginia in Charlottesville in 1826, but John Allan always provided less money than was

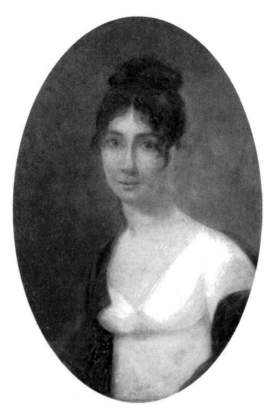

Poe's foster mother, Frances Keeling Valentine Allan, wife of John Allan. While known to be a hypochondriac, she was the one member of the Allan household to display some affection for Edgar. Poe's friend Robert Sully did this painting. *Courtesy of Edgar Allan Poe Museum, Richmond.*

actually needed for tuition and living expenses. To make ends meet, Poe often gambled. It is likely that he had dinner with Thomas Jefferson, founder of the college, in one of the former president's regular fêtes with students.

After only a year at the university, Poe decided to join the army, using the name Edgar Perry. His participation in the Riflemen may have, in part, made military life seem compelling, but more likely, his dire poverty forced him to look for ways to eat and survive. He was stationed in Boston and then Fort Moultrie on Sullivan's Island, South Carolina. The island's stories of pirates and treasure provided inspiration and the setting for several popular stories, including "The Balloon Hoax," "The Oblong Box" and "The Gold Bug."

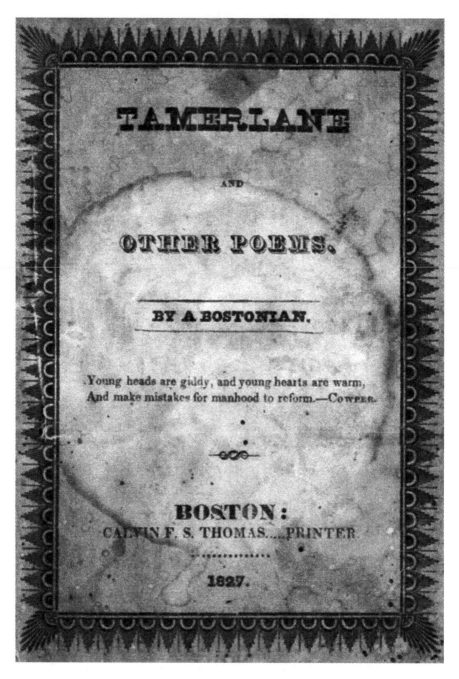

Opening page for *Tamerlane and Other Poems*, which Poe wrote when he was seventeen. Published in 1827, only fifty copies were printed. Like Hiram Haines, Poe initially omitted his real name, preferring to be called "A Bostonian."

Frances Allan, Poe's foster mother and the primary female figure in his early life, died in 1831. Allan helped his unhappy foster son obtain a release from the army and pulled some strings to secure a place for him in the military academy at West Point. Allan, perhaps in some twisted power play, still never provided Poe with enough funds to live as a normal cadet. Disgusted, Edgar managed to get himself expelled.

In 1831, after a brief and unproductive stay in New York, and after having been completely shunned by his aging foster father in Richmond, Edgar Poe moved to Baltimore to stay with family. The household included his aunt, Maria Clemm, her young daughter, Virginia, Poe's grandmother and his brother Henry. It was most likely in Baltimore that Poe began his transformation from a poet to a writer of imaginative short stories. By 1831, Poe had published three collections of his poems with little financial and only minor critical success. Although poetry clearly was and would remain his first love, it seemed obvious that Poe would need to expand his repertoire if he hoped to make a living as a writer. In 1827, Poe's brother, William Henry Leonard Poe, published in the *Baltimore North American* a fictional narrative titled "The Pirate." (Henry, as he was always called, lived most of his short life in Baltimore and published a number of poems and other pieces in the *Baltimore North American.* For a time, Henry appeared to have been employed as a sailor, possibly the inspiration for Poe's *Narrative of Arthur Gordon Pym.*) Henry, who had suffered from tuberculosis ever since he and Edgar had last met in 1827, succumbed to the disease in August 1831.

This engraving by miniaturist A.C. Smith shows Poe as he looked in the late 1830s–early 1840s, without his mustache. Poe was not impressed with this image, however, and said that it was better as an engraving than as a portrait. "It scarcely resembles me at all," he wrote.

Perhaps encouraged by his brother's brief success, Poe began to write stories. By 1833, Edgar had written eleven prose extravaganzas he hoped to publish as a set under the title *Tales from the Folio Club*. While living in Baltimore, Poe had sent collections of some of his works to various New York publishers but met with rejection. Finally, Poe's first success at being paid for his writing came in 1833, when his short story "Manuscript Found in a Bottle" won a fifty-dollar prize in a contest sponsored by the *Baltimore Saturday Visitor*. One of the editors, John Pendleton Kennedy, took an interest in the young writer and was helpful to Poe from this point on in his career. While the money was nominal, the prize proved that Poe could earn money as a writer.

A year later, in 1834, John Allan died, leaving his foster son absolutely nothing. In March 1835, Poe asked for Kennedy's help in securing a teaching position advertised in a newspaper. The position was filled before Poe could apply. But even better prospects were in the offing. One of Kennedy's friends, Thomas Willis White, had begun publishing a new magazine, the *Southern Literary Messenger*, in August 1834. On Kennedy's recommendation, White read and accepted several of Poe's stories, all published in the new magazine in 1835.

The first story, "Berenice," created a minor uproar among readers. Its subject matter— premature burial—was considered a bit too horrific for a "literary" magazine and bordering on questionable taste. These complaints, however, may have served as a catalyst to further immerse Poe into a genre of horror and the macabre. He pointed out to White that such stories

Thomas Willis White was the owner and founder of the *Southern Literary Messenger*. He gave Poe his first editorial job and periodically insisted that his employee stop drinking. *Courtesy of Edgar Allan Poe Museum, Richmond.*

Richmond offices of the *Southern Literary Messenger*, where Poe worked during his honeymoon with Virginia Clemm. The magazine was located on the second floor. The building to its right was owned by the Ellis and Allan firm, in which Poe's foster father was a partner. *Courtesy of Edgar Allan Poe Museum, Richmond.*

increased circulation by appealing to a broad audience. But the fact that they were carefully plotted and crafted raised them to a level far beyond pandering to the sensation-seeking public. "Great attention must be paid to style, and much labour spent in their composition, or they will

degenerate into the turgid or the absurd," Poe reasoned. White trusted Poe's rationale and went on to publish "Morella" in April, "Lionizing" in May and "Hans Phaall, a Tale" in June.

White realized that Poe's value might lie beyond his contributions of short stories, so he offered him a position at the *Southern Literary Messenger*. In the summer of 1835, Poe prepared to leave Baltimore to take on his new job. There was only one problem: he was deeply attached to his young cousin, Virginia Clemm, and it was beginning to look as if she would not remain with her mother much longer.

Virginia was barely thirteen, plump and positive. Her personality, according to some biographers, was innocent, cheerful and uplifting in a household plagued by poverty, age and illness. Her fondness for her big cousin Eddy was one of the few things to keep Poe going through a difficult period. The two were often seen playing hop-frog in Richmond parks. She called him "Eddy," and he in turn always referred to her as "Sissy."

Poe's grandmother had died in the spring of 1835 at age seventy-nine, leaving Maria Clemm without a steady source of income. The modest pension from her husband, "General" David Poe, was nearly all that had kept the family going for some time. Maria's brother-in-law, Neilson Poe (who was also a cousin), was financially stable and offered to take in Virginia and provide her with a good education, comfort and financial security. The thought of losing Virginia for good troubled Poe deeply. Somewhere along the line, his fondness for the young woman had turned to love, if not obsession. From his new residence in Richmond, Poe wrote Maria in what is the most passionate plea of his life:

> *My dearest Aunty,*
>
> *I am blinded with tears while writing this letter—I have no wish to live another hour. Amid sorrow, and the deepest anxiety your letter reached— and you well know how little I am able to bear up under the pressure of grief. My bitterest enemy would pity me could he now read my heart. My last my last my only hold on life is cruelly torn away—I have no desire to live and will not. But let my duty be done. I love, you know I love Virginia passionately, devotedly. I cannot express in words the fervent devotion I feel towards my dear little cousin—my own darling. But what can [I] say? Oh think for me for I am incapable of thinking. Al[l of my] thoughts are occupied with the supposition that both you & she will prefer to go with N. [Neilson] Poe. I do sincerely believe that your comforts will for the present be secured—I cannot speak as regards your peace—your happiness. You*

have both tender hearts—and you will always have the reflection that my agony is more than I can bear—that you have driven me to the grave—for love like mine can never be gotten over. It is useless to disguise the truth that when Virginia goes with N.P. that I shall never behold her again—that is absolutely sure. Pity me, my dear Aunty, pity me. I have no one now to fly to. I am among strangers, and my wretchedness is more than I can bear. It is useless to expect advice from me—what can I say? Can I, in honour & in truth say—Virginia! do not go!—do not go where you can be comfortable & perhaps happy—and on the other hand can I calmly resign my—life itself. If she had truly loved me would she not have rejected the offer with scorn? Oh God have mercy on me! If she goes with N.P. what are you to do, my own Aunty?

I had procured a sweet little house in a retired situation on Church Hill—newly done up and with a large garden and [ever]y convenience—at only $5 month. I have been dreaming every day & night since of the rapture I should feel in [havin]g my only friends—all I love on Earth with me there, [and] the pride I would take in making you both comfor[table] & in calling her my wife. But the dream is over [Oh G]od have mercy on me. What have I to live for? Among strangers with not one soul to love me.

The situation has this morning been conferred upon another. Branch T. Sunders. but White has engaged to make my salary $60 a month, and we could live in comparative comfort & happiness—even the $4 a week I am now paying for board would support us all—but I shall have $15 a week & what need would we have of more? I had thought to send you on a little money every week until you could either hear from Hall or Wm. Poe, and then we could get a [little] furniture for a start for White will not be able [to a]dvance any. After that all would go well—or I would make a desperate exertion & try to borrow enough for that purpose. There is little danger of the house being taken immediately. I would send you on $5 now—for White paid me the $8 2 days since—but you appear not to have received my last letter and I am afraid to trust it to the mail, as the letters are continually robbed. I have it for you & will keep it until I hear from you when I will send it & more if I get any in the meantime. I wrote you that Wm. Poe had written to me concerning you & has offered to assist you asking me questions concerning you which I answered. He will beyond doubt aid you shortly & with an effectual aid. Trust in God.

The tone of your letter wounds me to the soul—Oh Aunty, aunty you loved me once—how can you be so cruel now? You speak of Virginia acquiring accomplishments, and entering into society—you speak in so

*worldly a tone. Are you sure she would be more happy. Do you think any
one could love her more dearly than I? She will have far—very far better
opportunities of entering into society here than with N.P. Every one here
receives me with open arms.*

*Adieu my dear aunty. I cannot advise you. Ask Virginia. Leave it to her.
Let me have, under her own hand, a letter, bidding me good bye—forever—
and I may die—my heart will break—but I will say no more.*
EAP.
Kiss her for me—a million times.

As was often the case in Poe's life, a positive turn of events was overshadowed
by the darkness of depression over his emotional circumstances. By this point, he
had a new job, and his story "Manuscript Found in a Bottle" had been included
in a popular keepsake anthology called *The Gift* produced for the Christmas
market. He began drinking in local taverns while waiting on Virginia's ultimate
fate and then left his job to return to Baltimore to press his case.

That desperate visit seemed to have done the trick. Virginia accepted his
proposal, and they secured a marriage license in Baltimore on September
22, 1835.

Virginia and her mother returned to Richmond with Poe on October 1
and settled into Mrs. Yarrington's Boarding House opposite the Capitol and
just a short walk to the offices of the *Messenger*. Thomas Willis White, who
had put up with Poe's leave of absence, warned Poe that he would lose his
job for good if he began drinking again. Heeding the warning, Poe sank
himself into reading the work of others and issuing literary criticism, which
also made him a more critical editor of his own work.

The marriage to this point had been clandestine, a vehicle for keeping the
Clemms and Edgar together. By May 1836, however, Edgar was ready and
eager to go public. It would be embarrassing if anyone in Richmond learned
that he had been secretly married to a child, but with a paying job and some
doctoring of the marriage certificate, a cloak of respectability would be
maintained. On May 16, 1836, Edgar Allan Poe and Virginia Clemm were
openly married at Mrs. Yarrington's Boarding House in Richmond. Poe was
twenty-seven years old. While Virginia was still thirteen years of age and a
first cousin, official documents list her as being twenty-one.

Mrs. Clemm and Virginia undoubtedly had waited patiently for this
official marriage, having endured an earlier ceremony without guests, cake
or even a ring. The marriage bond, which was signed in the Hastings Court
of the City of Richmond, records that the oath was taken before Charles

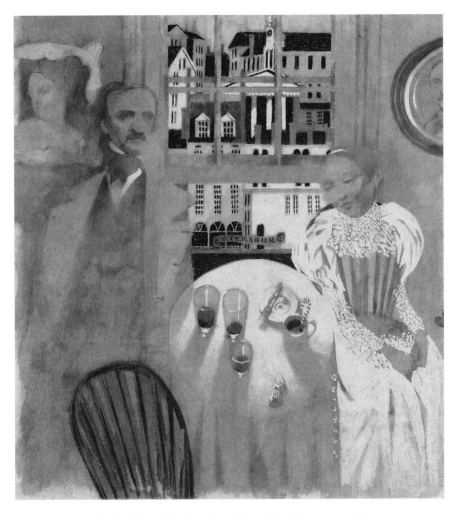

Richmond artist Sterling Hundley's haunting vision of Poe's honeymoon illustrated an article the author wrote for *Richmond* magazine, marking Poe's 200th birthday. Signed and numbered prints are available.

Howard, the clerk of the court, and Thomas Cleland as witnesses that "Virginia E. Clemm is of the full age of twenty-one years." Biographers point out that Cleland, a devout Presbyterian, was certainly reassured of Virginia's maturity in years, if not appearance, by all parties involved or he would likely not have agreed to take part.

According to Poe biographer Hervey Allen, on the day of the marriage, Jane Foster, a young acquaintance of Mrs. Yarrington from the outskirts of

Richmond, came to visit her friends in town. She found Mrs. Yarrington and Mrs. Clemm baking a wedding cake for the impending marriage. Late in the afternoon, guests began to arrive—Mr. White and his daughter Eliza; Mr. and Mrs. Cleland; William MacFarland and John Fergusson, the printers of the *Messenger*; Mrs. Yarrington; Mrs. Clemm; and Jane Foster.

Reverend Amasa Converse, a Presbyterian editor of the *Southern Religious Telegraph*, performed the marriage in the boardinghouse parlor. Virginia was dressed in a traveling dress and a white hat with a veil. Poe, as usual, was dressed in a black suit. Jane Foster, who was quite young herself, remembered Virginia's childlike appearance. Reverend Converse also noted that Virginia had "a pleasing air" but did seem very young. After the ceremony, the boarders in the house were invited to take part in the celebration, enjoying wine and cake.

According to Allen:

> *After the humble felicitations, a hack was called to the door, and Virginia and Edgar drove off together on their honeymoon. One catches a glimpse of the waving hands of the boarders, the fat stack of the little, wood-burning locomotive throwing sparks on Virginia's traveling dress on the short journey to Petersburg, and a round of entertainments at various friends' houses in the quiet little town basking in the sunlight and perfume of a Virginia May. The paulownia trees were in bloom.*

It sounds lovely. But unfortunately, as thorough and comprehensive as Allen's 1935 biography is, he has painted a romantic image not based on fact. No evidence of a railroad connection between Richmond and Petersburg exists until 1838, two years after the honeymoon. So how did the couple make the twenty-mile voyage south? Most likely they took advantage of the regular coach service between the two towns. The Half Way House, an inn-restaurant built in 1760, still operates on Highway 1 in south Richmond. In the late eighteenth and early nineteenth centuries, it served as a rest stop and horse change for the Petersburg coach. Mr. and Mrs. Poe very likely got out to stretch their legs there before continuing their trip to Petersburg just as Poe's mother, Eliza, would have done a generation earlier in traveling between the two city's theaters.

Poe's decision to visit Petersburg and Hiram Haines' Coffee House was both convenient and logical. Petersburg was a center of amusements such as horse racing, theater and numerous taverns within a few blocks of one another. It was, in many ways, like running up to the Catskills or Atlantic

City after being married in New York City. It was also a place offering a tolerant, even bohemian atmosphere, much like it does today. Petersburg was free of the social or moral distinctions of Richmond, and people of many races and creeds, including a very large African American population, easily mingled on the same streets and parks. It was the perfect place to take a child bride of thirteen trying to pass for twenty-one.

By this point, Poe certainly knew Hiram Haines and had visited him and his childhood playmate, Mary Ann Philpotts Haines, at least once, if not numerous times. With four children of their own, and possibly a mother-in-law, in the house adjacent to the Coffee House, Haines would have been honored to offer the couple a "honeymoon suite" above the Coffee House itself. We don't know whether Hiram secretly whispered Virginia's true age to Mary after hours, nor do we know what Mrs. Haines' impressions were of her childhood friend's choice in a bride. We do know that regular visitors to Petersburg, and the Coffee House, were an eclectic blend of intellectuals, journalists, craftsmen, aristocrats, wanderers and performers, mulattos, creoles, Haitians, Jews, Scotsmen—in short, a cross section of Petersburg's crazy-quilt citizenry. There was likely very little about a blossoming poet and writer and a child bride that would have shocked anyone. And her age, officially listed as twenty-one, was likely passed off as the truth in Petersburg as well.

Unless the details were recorded in a lost diary of one of the parties involved, Poe's arrival and Mr. and Mrs. Haines' greeting of the couple has been relegated to purely fictional accounts. The first, "The Very Young Mrs. Poe," written by Cothburn O'Neal in 1956, creates a scenario that, aside from the real names being used, is purely imaginary and inaccurate. Considering the historical information available at the time, largely through the *Journal of the College of William and Mary*, it would have been possible to write a considerably truer story.

If history repeats itself, it seems that inaccurate history does the same. In 2012, Lenore Hart's novel *The Raven's Bride* repeats the plot details of the earlier novel almost verbatim, to the degree that she has been accused of plagiarism by some Poe aficionados. Of the honeymoon trip itself, O'Neal erroneously placed the couple on a train to Petersburg from Richmond when, in fact, coach was still the only viable overland route. O'Neal wrote:

> *The trip, something over twenty miles, took about an hour. The train crossed the Appomattox after sunset, but pulled into the Petersburg depot before dark. Their host, Mr. Hiram Haines, publisher of the* Petersburg

American Constellation, *was waiting with his wife. He was a cheerful, balding man with heavy sideburns and twinkling eyes. Mrs. Haines was all twinkle. Sissy loved them both at first sight.*

"Welcome to Petersburg," Mr. Haines said jovially. "You will want to ride back here Mrs. Poe. This is Mrs. Haines."

"Mrs. Poe!" He was the first one to call her that. He helped her into the back seat of the surrey where Mrs. Haines was sitting, and then took Eddy up front with him.

"Did the trip tire you, Mrs. Poe?" Mrs. Haines asked as her husband clucked the horses into motion.

"No, I enjoyed it very much."

"Of course. Imagine my asking a bride if a train trip tired her on her wedding day. They didn't have trains when I was married. We rode all day in a stagecoach. But I don't think I was tired either. A girl gets married only once—a nice girl, that is."

Now, the same circumstances as written by Hart in *The Raven's Bride*:

We crossed the Appomattox after sunset and rolled into the Petersburg depot before full dark. As we descended from the car Eddy spotted our host, Hiram Haines, the cheerful, balding publisher of The American Constellation. *What Mr. Haines' pate lacked in hair he made up for with enormous muttonchop whiskers. His smile pushed cheeks up into twin red apples.*

"Welcome to Petersburg, Mrs. Poe," he boomed. I looked at him blankly, then quickly bowed to hide my flaming face. He was the first to informally address me so. His wife, who sat smiling in their surrey, waved to us. Then her husband helped me up into the back with her, and we took off for our honeymoon abode, the Haineses' country house.

Hiram Haines asked whether the trip had tired me out.

"No, not a bit," I assured him. Then, fearing that sounded rude, added "Well, perhaps a little."

Mrs. Haines laughed. "Pshaw. She can't possibly be tired, Mr. Haines. Remember back when we wed? There were no trains then so we rode all day long on a stagecoach to our honeymoon cottage. And yet I was not fatigued, not one little bit!"

As noted by a number of contributors to online Poe forums, Lenore Hart's book borrows heavily from the O'Neal book. In many instances, certain passages are even more similar than the ones cited here. Determining

whether or not this ventures into the possibility of plagiarism is not my purpose. What does matter, however, are the known facts. In this instance, we now know that Hiram Haines was neither bald nor fitted with mutton chops and that the couple did not arrive by train. The Petersburg-Richmond train was not running until two years later.* There was no Haines country house, only the three-story building adjacent to the Coffee House in which they stayed.

I personally take exception to the simplistic "Ma and Pa Kettle" characterization of the Haineses in both books. Haines was older than Poe by seven years, for sure. But he and Mary were still only in their thirties and were actively involved in the community, publishing and politics, as well as the raising of a very young family. Articulate, well read and physically active, they were certainly not the stodgy couple depicted in these fictional accounts.

The majority of written accounts state that Eddy and Sissy spent their honeymoon at Hiram Haines' Coffee House; a few, including the fictional accounts, place them at Hiram Haines' "house." The fact that the Coffee House and "manse" were connected side by side is important. Either building could be referred to as the Haines residence.

Oral histories and local traditions place the couple in the second-floor suite directly above the Coffee House, the only logical place for honeymooners to stay. Haines' home was crowded with a wife, four children, including a crying infant, and a mother-in-law. The second-floor suite of what is now No. 12 West Bank Street was designed to be the residence of the owners of the business below and was created to the

* The Richmond and Petersburg Railroad was chartered in 1836 but did not begin service until 1838. While a decade later the city became a major hub of rail transportation, not everyone was happy at the thought of a quicker connection between Richmond and Petersburg. Many local business interests closely guarded the town's commercial position in the region and were worried that a better connection to Richmond might siphon trade being done in Petersburg to the larger capital city. Known as "dammers," these opponents couldn't stop construction of the new rail line, but they managed to prevent it from making direct connections with the existing Petersburg Railroad, which connected the town to the upper Piedmont region of North Carolina.

As a result, all southern-bound freight reaching Petersburg from Richmond had to be unloaded, placed on wagons and then hauled to the Petersburg Railroad depot for reloading. The result made things a little less convenient than they might have been but kept a lot of draymen and wagoners busy doing the work they would have lost otherwise.

The living room of the honeymoon suite, which now overlooks a covered alley and a second building in the rear. In Poe's time, the alley would have been wide open and convenient to parking a horse or carriage in the back. *Photo by John Rooney Jr.*

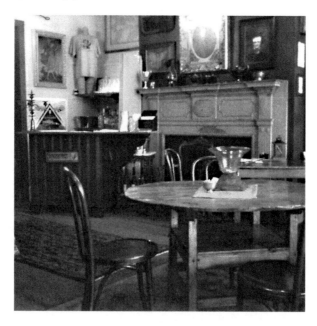

The original mantel from the honeymoon suite is temporarily housed in the main room of Hiram Haines Coffee and Ale House for visitors to enjoy. Created in 1814, when the building was constructed, the mantel represents the highest-quality craftsmanship in the region at the time. The centerpiece is known as a Petersburg Sunburst.

Doors of the upper level of Hiram Haines Coffee and Ale House show the rooms where boarders or nightly visitors stayed, beginning in 1814. Civil War soldiers stayed here during the Siege of Petersburg, suffering from fatigue and malnutrition. Psychics have claimed that a nurse still walks these rooms tending to their needs. *Photo by Jeffrey Kyle Rayner.*

highest standards of elegance available in Petersburg. It provided easy access to the stables at the rear and the dining areas on the main level. The upper level was subdivided into individual rooms for boarders. A wider landing offered storage room for travelers and likely a water closet.

Poe and Hiram Haines were clearly already good friends before the honeymoon. In some ways the two men were quite different. Poe was urbane, educated, well dressed, articulate and proud. Hiram was largely self-taught, "raised of the plow" by his own admission, humorous and active in the local community. But he was also known to be proud and fiercely independent, as Poe noted years later. Both men were published writers and working editors at the time. Poe had not yet received any large degree of fame, but Haines was filled with admiration, perhaps awe, of what the young Poe, seven years his junior, was capable of writing. At this juncture, both were clearly and expressively in love with their wives, as well as the written word, and both had much to gain through a symbiotic relationship through which their respective publications could be promoted.

Historians note that the Poes visited several Petersburg households, notably those of another journalist, Edwin V. Sparhawk, a former editor of the *Literary Messenger*, and Dr. William M. Robinson. Robinson, a prolific

painter, writer and doctor, noted later that Poe's conversation was brilliant. Poe returned the compliment, noting that Robinson was one of the six best conversationalists he had ever met.

Biographer Hervey Allen, one of the few to cover the Petersburg honeymoon at all, was most likely in error, however, when he wrote: "Poe no doubt noticed, although he enjoyed it, that the conversation of the others was somewhat bucolic. He was already longing for more cultivated fields in which to converse largely."

This assumption on the part of the biographer is not only presumptuous but most likely dead wrong. Some of the best minds of the region were living in Petersburg at the time, as well as the most profitable tobacco merchants, bankers, booksellers, painters and theologians. The town was culturally rich and thriving. Allen notes that by the end of the month, the couple returned to Richmond. Other historians have confirmed the fact that the couple stayed for roughly two weeks. Had Petersburg been as "bucolic" as Allen implied, they likely would have headed home much sooner. There were also plenty of diversions in Petersburg—racetracks, taverns, theaters and walking paths beside the river, and it is very likely that Virginia entertained Poe by playing the pianoforte owned by Hiram and Mary. It may well have been housed in the Coffee House for entertainment.

Invariably, the question of whether the marriage,

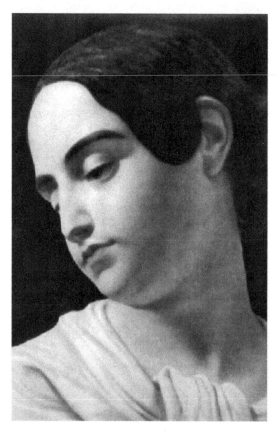

Ironically, the only existing portrait of Virginia Clemm done "from life" was painted shortly after her death. Poe, realizing that he had no image of Virginia to remember her by, quickly commissioned an unnamed painter to capture her shortly after she had expired.

in fact, became a real marriage during the honeymoon arises. Some biographers claim that Poe had promised his aunt to wait until Virginia was older.

In *The Raven's Bride*, Mrs. Haines, an educated woman from a wealthy Richmond family, is reduced to a cliché of a housebound Victorian twit over dinner:

> *The men talked of the publishing business and the people they knew between them who were in it. Mrs. Haines asked me if we would live in Richmond when we returned.*
>
> *"Oh yes," I said. "My husband—" I hesitated at this unfamiliar phrase, then plunged on. "My husband has a position there with a magazine."*
>
> *"Oh, that's nice. And you will keep the house, while he does the work much like my husband's."*
>
> *"Yes, I suppose so. When I'm not taking lessons in music and voice."*
>
> *She frowned. "Lessons? But you are married now. That sort of thing must fall by the wayside when you have a home and family."*
>
> *I looked at my plate. "Oh really? But I had thought—"*

Shortly thereafter, it's time for bed. According to Hart's Virginia:

> *Eddy, who'd been so jovial and charming, fell quiet. He silently took my arm and we ascended the wide staircase, which we could walk side by side.*
>
> *He paused at the landing. "I've left something downstairs. You go ahead, Sissy. I'll join you in a moment."*

Virginia proceeds to the room, undresses and gets into bed. Waiting for some time, she dozes off and then is awakened by her husband's presence, at last. To her dismay and anger, he tells her that he has promised her mother to refrain from intercourse until she is a little older.

Oddly, in Cothburn O'Neil's version of the same events, published more than fifty years earlier, the consummation of the marriage is subtly implied: "That night Sissy learned the full measure of Eddy's tenderness, of his need for her. And when she entered into the first mystery of wifehood, she was happy in his arms, thankful that she had proved adequate. She was no longer a little girl weaving wishes into a Blossom Band."

Of course, a work of fiction is exactly that—fiction. But when real life people are represented, and the truth is known about the details, presenting that truth would seem to help the work, not detract from it.

The living room on the second floor still houses the original moldings, paint, fireplace mantel and flooring. These rooms had been unoccupied and unused since the 1950s. Prior residents had apparently been respectful of its history, since very little was ever changed or disturbed. Typically, a painting would have hung over the mantel to cover the hole for the fireplace cleanout. *Photo by Jeffrey Kyle Rayner.*

> Ever with thee I wish to roam —
> Dearest my life is thine.
> Give me a cottage for my home
> And a rich old cypress vine,
> Removed from the world with its sin and care.
> And the tattling of many tongues.
> Love alone shall guide us when we are there —
> Love shall heal my weakened lungs;
> And Oh, the tranquil hours we'll spend,
> Never wishing that others may see!
> Perfect ease we'll enjoy, without thinking to lend
> Ourselves to the world and its glee —
> Ever peaceful and blissful we'll be.
> Saturday February 14. 1846.

This handwritten Valentine, dated February 14, 1846, indicates the devotion Virginia felt for Edgar Poe. Though she was known to be upset over rumors about him and other women, it was, by all accounts, a happy marriage. Though remembered as a child bride, these words of love came from a twenty-three-year-old woman.

Hopefully, *Edgar Allan Poe's Petersburg* will set the record straight, at least concerning true history.

One fact that emerges in virtually all descriptions of Mr. and Mrs. Poe's marriage is their devotion to each other. They had gone from playing leapfrog like children in Richmond's parks to setting up an adult household

where Edgar could write and Virginia could play their pianoforte and sing. Evidence of her undying devotion to him appeared in the 1846 Valentine's Day poem:

Ever with thee I wish to roam—
Dearest my life is thine.
Give me a cottage for my home
And a rich old cypress vine,
Removed from the world with its sin and care
And the tattling of many tongues.
Love alone shall guide us when we are there—
Love shall heal my weakened lungs;
And Oh, the tranquil hours we'll spend,
Never wishing that others may see!
Perfect ease we'll enjoy, without thinking to lend
Ourselves to the world and its glee—
Ever peaceful and blissful we'll be.
 Saturday February 14, 1846

Ten years earlier, in late 1836, back in Petersburg, Hiram Haines' fortunes took a turn for the worse. Both the *Constellation* and the Coffee House had trouble collecting debts. The advertisement shown on page 73 told his customers in no uncertain terms that he had waited long enough.

Ultimately, he was forced to put everything in the Coffee House up as collateral for the debts he owed personally, as listed in articles of indenture as security for Herbert Whitman and the Bank of Virginia in the Petersburg Courthouse. Among the collateral listed were: one sofa, one pianoforte, one sideboard and tables, one dining room set, two card tables, one tea table, one large mirror, two dozen chairs, three carpets, five bed stands, beds and bedding, one brass grate and fender plus "whole of other household furniture including: table and tea chairs, whole of kitchen furniture, whole of Haines' library comprising about 200 volumes and whole of subscriptions due to said Haines on account of his Coffee Establishment, plus all the debts due on the books of the *American Constellation*, all the typefaces, case stands and other printing and preparing instruments; the desks and other counting room furniture."

By 1838, having secured his debts through personal property, Coffee House inventory and the monies due the *Constellation*, Haines was financially in a downward spiral. Like Poe, he had known money problems all of his

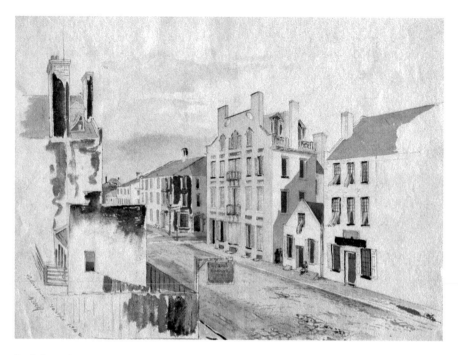

Bank Street in 1842 was considerably more densely habitated than it is today. The building to the far right butts against an important structure the artist neglected to include, Hiram Haines' Coffee House. By then it had been taken over by other owners. The small cottage to its left remains, but most everything else in the picture is gone or dramatically altered.

life, but he still looked to his relationship with Mary, and the support of good friends, as the bedrock of his most important wealth:

September 10, 1838

With the real love we have for each other, as you justly remark, we are indeed rich, richer by a great deal than hundreds of thousands, who are apparently better off, but whose wealth and happiness is at best but an outside show. The world has dealt harshly with us, much more so than I have dealt with it—besides the misfortune of suffering the revenues, which I foresaw for years before they overtook me to weigh too heavily on my mind, I have nothing to look back upon with regret. My errors, and they have been in some respects many and great, are more justly chargeable to the Destiny which fashioned my mind and ruled its actions, than to myself. No doubt, I was led or suffered to run into them for purposes as inscrutable as they may in the end prove beneficial to me and mine. It's as singular as it is true, that in every desperate affliction or emergency, I have never wanted friends of the most serviceable character. Why

110

have I been thus protected and aided, while others have irretrievably fallen? But a truce to moralizing—my paper is giving out and I must close.

There was an unintended double meaning to Haines' last line, the last, in fact, of all his preserved letters. The paper on which he was writing was running out of space, and the paper he was publishing was about to go into other hands.

Haines relinquished control of the *Constellation* at the end of 1838 but couldn't be kept down. In 1839, he started a new paper that seems alternately to have been called the *Time O' Day* as well as *Peep O' Day*, neither of which seemed to appeal to the public. In 1840, he found better success with the *Virginia Star*, which he continued to publish until his death in January 1841.

History indicates Poe had not forgotten his old friend Hiram Haines and published a glowing review of his newspaper and his personality in *Alexander's Weekly Messenger* in 1840.

> THE VIRGINIA STAR.
> *This is the title of a new weekly and tri-weekly paper, published at Petersburg, Va., by H. Haines, Esq. late editor of the Petersburg "Constellation." Mr. Haines is a gentleman of education and of unusually fine talents. He is, moreover, a sternly independent man; and this is saying a great deal in these days of universal subserviency and tergiversation. The "Star" will be a "bright particular" one, indeed, if it emit rays one half so brilliant as those from the "Constellation" of old days. No mere constellation that—but a perfect galaxy of good things. In faith, we remember it well. Neither Mr. Haines, nor any papers of Mr. Haines, are matters to be readily forgotten.*
>
> *The "Virginia Star" is a pretty-looking sheet, well printed, on excellent paper—its matter (whether editorial or contributed) equal to that of any printed in America. It proceeds upon the cash system—quite a novel idea in Virginia. We cordially wish it a life of a thousand years.**

In turn, Haines promoted Poe's work in the *Virginia Star*. In the edition of Saturday, December 19, 1840, he mentioned a new work that appeared in *Graham's Magazine*:

> *Among the contributions in the December 1840 number of* Graham's Magazine *is "The Man of the Crowd," from our valued friend and*

* This notice was first attributed to Poe by Clarence S. Brigham, *Edgar Allan Poe's Contributions to Alexander's Weekly Messenger* (n.p., 1943): 58–59.

literary favourite, Edgar A. Poe, Esq, whose every line is stamped with the impress of his vivid genius and powerful intellect. We shall copy it, and if our readers do not pronounce it the most thrilling and graphic piece of description they have ever perused, we shall be deeply disappointed.

In the 1930s, after a bit of bargaining, Haines' descendants sold two of Poe's letters to Hiram Haines to Richmond's Poe Museum for $600. One was written in 1836 while Poe was at the *Southern Literary Messenger*:

Herewith I send you the August number of the "Messenger"—the best number, by far, yet issued. Can you oblige me so far as to look it over and give your unbiased opinion of its merits and demerits in the "Constellation"? We need the assistance of all our friends and count upon you among the foremost.

The contributions have, in most cases, the names of the authors prefixed. All after the word Editorial is my own.

If you copy any thing please take my Review of Willis' "Inklings of Adventure"—or some other Review.

With sincere respect

Yr ob. St

Edgar A. Poe

The other letter to Haines was sent from Philadelphia in April 1840. Haines had written Poe and Virginia, offering them the gift of a fawn. One can only speculate that Virginia had seen similar animals in Haines' backyard and expressed a desire for one. Unfortunately, as Poe points out, it was not a very practical gift:

My Dear Sir,

Having been absent from the city for a fortnight I have only just received your kind letter of March 24th and hasten to thank you for the "Star," as well as for your offer of the fawn for Mrs. P. She desires me to thank you with all her heart—but, unhappily, I cannot point out a mode of conveyance. What can be done? Perhaps some opportunity may offer itself hereafter—some friend from Petersburg may be about to pay us a visit. In the meantime accept our best acknowledgments, precisely as if the little fellow were already nibbling the grass before our windows in Philadelphia.

I will immediately attend to what you say respecting exchanges. The "Star" has my very best wishes, and if you really intend to push it with

The Untold Story of the Raven in the Cockade City

The 1836 letter from Edgar Allan Poe to Hiram Haines now owned by Richmond's Poe Museum. Promotion of each other's editorial interests was an important aspect of the two men's friendship.

Letter to Hiram Haines from Edgar Allan Poe from Philadelphia. Herein, Poe politely declines Haines' offer to send Virginia a fawn. "What can be done?" Poe asks. There is simply no place to keep such a pet.

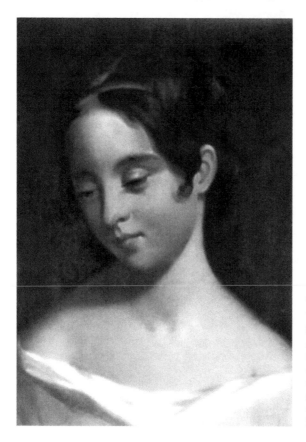

This, the second portrait of Virginia Clemm by Thomas Sully, portrays a more childlike, innocent persona. Some Poe historians feel that there were images of Virginia taken from life, including daguerreotypes, but they were kept hidden because of her young age.

energy, there cannot be a doubt of its full success. If you can mention anything in the world that I can do here to promote its interests and your own, it will give me a true pleasure.

It is not impossible that I may pay you a visit in Petersburg, a month or two hence.

Till then, believe me, most sincerely."

Your friend

Edgar A Poe

H. Haines Esqr

There was certainly considerably more correspondence between the two men. An article in the *Petersburg Express* in 1857 made reference to a package of letters Poe had written in 1839 to a "literary and political man" in Petersburg thought to be Hiram Haines. This package has yet to be discovered.

CHAPTER 8

POSTMORTEM

Hiram Haines died on January 14, 1841, of what was officially recorded as bilious pleurisy. It may have been pneumonia or any number of illnesses that are easily treatable today. Despite his dreams of growing old and being buried side by side with Mary, death claimed him early, just as it would his friend Eddy Poe eight years later. The obituary in the *Petersburg Star* praised its former editor:

> *Death of Hiram Haines, Esq.*
> *It is with feelings of the deepest regret, that we are called upon to announce to our friends and readers the death of* HIRAM HAINES, *Esq., late Editor of this paper. He expired last evening, at Hickory Hill, Prince George County, after an illness of a few days, of bilious pleurisy; leaving an aged father, a disconsolate wife, and six small children to mourn his early death. We knew the deceased well—and can say with truth, that it has never been our fortune to become acquainted with any man who was influenced in all his actions by more honorable and generous feelings. He was warm hearted and devoted to his friends, and harbored no feeling of enmity towards any human being. Those who knew him—and he had many friends—will long remember his inestimable worth—his blameless integrity—his uniform kindness to all, and the characteristic generosity, always ready to palliate offenses, and never disposed to "set down aught in malice." He has left a blank in the Editorial corps, which cannot be easily filled. Mr. H was in the 38th year of his age.*—Petersburg Star.

Mr. Haines was a man of taste and talents, and was a very efficient Editor when he conducted a political paper. He had some high qualities, and was a member of that fine corps, the Volunteers of Petersburg.—Enquirer.

Of Hiram Haines' six children, the youngest, Oakley Philpotts Haines, born December 29, 1837, best carried on his father's legacy in the writing and publishing business. As a young man, he contributed to several magazines, including *Godey's* of Philadelphia and *Waverly* of Boston, and he was a favored contributor to the *Richmond Enquirer* and the *Kaleidoscope of Petersburg*. By 1861, he was working for the *Richmond Examiner*, followed by a job as the Confederate congressional reporter for the *Richmond Enquirer*. He also reported on war news from the fronts around Richmond and Petersburg.

Hiram Haines' gravestone as it now appears in restored condition in Petersburg's Blandford Cemetery. The quotation "Oh death the palm is thine" comes from poet Edward Young.

Haines witnessed numerous battles, most notably the Battle of the Crater in Petersburg, not far from Blandford Cemetery where his mother and father were buried. After the war, Oakley Haines moved to Baltimore to work for the *Sun*, and by 1881, he was managing editor of that major newspaper.

Though he was just an infant when his father died, Oakley Haines did know of his father's friendship with Edgar Allan Poe. As a student at the Presbyterian High School in Petersburg from 1850 to 1853, he was able to read Poe's works in their entirety and came to admire the author's genius.

In 1861, while reporting on the Virginia convention, he came across a daguerreotype of Poe in the

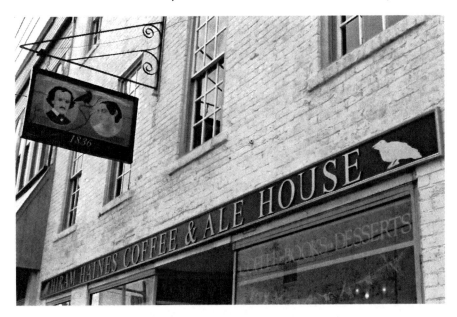

A new sign at Hiram Haines' celebrates the honeymoon and the year, 1836. The banner being held by the raven reads, "All that we see or seem is but a dream within a dream." *Photo by Jeffrey Kyle Rayner.*

Old Whitehurst Gallery and purchased it for five dollars, according to Haines' descendants. After the Civil War, the daguerreotype was lost somehow, though prints of the original began to emerge. Eventually, the valuable image was found to be in the possession of Neilson Poe, one of many Poe cousins, in Atlanta, Georgia. In 1875, when the Poe monument in Baltimore was dedicated, a commemorative book was published; the daguerreotype, called "the unequalled portrait" image, formed the frontispiece. According to the Haines family, Oakley had inadvertently left the image at Poe's house in Atlanta and was never able to get it back. As to its authenticity, the publishers relied on the testimony of the well-known photographer Daniel Bendann for confirmation: "The photograph of Edgar Allan Poe accompanying this volume is from the original daguerreotype taken at the old Whitehurst gallery, Main St., Richmond, (with which establishment I was myself for sometime connected), and is unquestionably, the most faithful likeness of him extant."

The image itself is faded and unavailable for republication. Poe looks slightly bloated, with a curled mustache, wearing his characteristically black attire. While the daguerreotype was gone forever from the Haines family's possession, Haines descendants did hold on to two letters Poe wrote to Hiram Haines until they sold them to the Poe Museum in Richmond.

The newly restored grave site of Mary Haines, who died in 1860. Hiram had written to her about growing old together and even being buried together so passersby could witness their devotion. Sadly, he died at age thirty-eight, and she never remarried.

A glorified painting of Virginia Clemm done by either Thomas Sully or Robert Sully. Still in the possession of descendants of Virginia's aunt, Elizabeth Poe Herring, the painting was obviously done from memory sometime after Virginia's death.

Mary Anne Philpotts Haines lived on until 1860, and while Hiram's loving wish that they be buried together in old age could not become reality, she is buried right next to him and her other family members near the western wall of Blandford Cemetery in Petersburg.

Virginia Clemm died in 1847 of tuberculosis. She and Eddy were living at their Fordham, New York cottage at the time. She did not rest in peace. In 1875, the same year in which Poe was reinterred to his current grave site, the grounds where Virginia lay were destroyed. William Gill, an early Poe biographer, found the sexton poised to throw her bones away as unclaimed. Gill took them and kept them in a box under his bed for years. Ten years later, through arrangements with family members, she was buried in a small casket next to her husband.

The years that they were together were likely the happiest of Poe's life and certainly the most productive. Perhaps the stability provided by marriage set loose his most creative energies. She may well have been the inspiration for two of his famous works, "The Raven" and "Annabelle Lee."

Edgar took the blow of her death hard. He was already known to be suffering from a heart condition, and it worsened under the stress of Virginia's passing. Theories abound as to the actual cause of Edgar Allan Poe's death on October 7, 1849. This and the circumstances of his honeymoon with Virginia have been two of the most mysterious aspects of his legacy.

POE'S DEPARTURE

Earlier in 1849, Poe's prospects had finally been looking good. He had achieved fame through "The Raven," as well as a broad public appreciation for the rest of his works. He was also readying to marry his first, and perhaps truest, love, Elmira Royster Shelton.

Later in the year, a strange series of events began. In September, Poe planned to visit Philadelphia about a book editing commission and then travel on to the Bronx to pick up Mrs. Clemm and take her back to Richmond for his wedding.

On September 25, a day after giving a lecture on "The Poetic Principle," his last completed work, in Richmond, he attended a small party at Talavara on West Grace Street, home of his friends, the Talley

This daguerreotype of Poe was taken in 1847, shortly after Virginia Clemm's death. Despite the tragic end, Poe felt that it was the highs and lows of her condition, the periodic false hopes that drove him to distraction. By the time of this photo, the future was beginning to hold new promise. *Courtesy of Edgar Allan Poe Museum, Richmond.*

family. Some accounts say he recited "The Raven" for the last time during this visit, as he had done on other occasions. On September 26, Poe spent the day with several old friends and visited Elmira in the evening. She noticed that he didn't look well and determined that he was hot with a fever. She didn't think he would continue traveling north. But the next day, she learned that he had visited Dr. John Carter after seeing her and then took the boat to Baltimore. By mistake, he had taken Dr. Carter's cane rather than his own. This was not something he was likely to do if he was mentally and physically well.

What happened next remains a mystery of missing time and circumstances. On October 3, Poe's Baltimore friend Dr. J.E. Snodgrass received a note that read:

> *There is a gentleman, rather worse for wear, at Ryan's 4ᵗʰ ward polls, who goes under the cognomen of Edgar A. Poe, and who appears in great distress, & he says he is acquainted with you, and I assure you, he is in need of immediate assistance.*
> *Yours, in haste,*
> *Jos. W. Walker.*

Snodgrass found Poe in an incoherent state, dressed in shabby clothes that were clearly not his own. Snodgrass and Henry Herring, the husband of Poe's aunt, Elizabeth Poe, took him to Washington College Hospital. The attending doctors noted his delirium but also the fact that he had not been drinking at all.

The Untold Story of the Raven in the Cockade City

The writer lapsed in and out of consciousness for days, and on the night of Saturday, October 6, he began to call out for "Reynolds," a name notable for having inspired *The Narrative of Gordon Arthur Pym*. Just before three o'clock in the morning on Sunday, October 7, Poe peacefully said, "Lord help my poor soul" and died. These last words, while certainly fitting, were also part of what was known as "the sinner's prayer" as regularly recited by the Sons of Temperance. Before sunrise, Edgar Allan Poe was dead of what the attending Dr. Moran called congestion of the brain—equally as innocuous as the bilious pleurisy that had killed his friend Hiram Haines.

What really killed Poe? And had whatever finally claimed his life been influencing his personality in later years?

Poe's death has been a heated topic of discussion for more than 160 years. Early theories suggested that he had been drugged by a "coop" gang that forced strangers to vote in one polling place after another to fix an election. This would explain not only his incoherence but his odd attire as well.

More recent theories suggest that he had contracted rabies from a stray cat. But Harry Lee Poe, contemporary author and professor and a distant cousin of the poet, suggests looking more closely at the known evidence. The source of his demise may ultimately have been the source of his genius as well—his brain.

There is evidence of a brain tumor that, while purely conjecture, might stir the pot of the tumor theory a bit. People with temporal lobe epilepsy often experience depersonalization-like symptoms. (I have studied depersonalization disorder [DPD] for more than thirty years and have written two books on the subject.) After looking at all the evidence, the brain tumor theory is most likely true, in my opinion.

Often, existential thinking and obsessive preoccupation with the nature of existence, the universe, God and the like is part and parcel to depersonalization. It is quite possible that abnormal activity in the temporal lobes, or perhaps other parts of the brain, particularly in a highly intelligent individual who is already concerned with "the big questions," could in fact result in the thinking behind, and the language of, something as advanced and bizarre (by conventional terms) as Poe's *Eureka*, published in 1848. As clearly implied in Poe's introduction, *Eureka* is nothing like anything else he had ever written, and it is challenging for anyone to read, let alone for short story fans:

> *To the few who love me and whom I love—to those who feel rather than to those who think—to the dreamers and those who put faith in dreams as in the only realities—I offer this Book of Truths, not in*

its character of Truth-Teller, but for the Beauty that abounds in its Truth; constituting it true. To these I present the composition as an Art-Product alone:—let us say as a Romance; or, if I be not urging too lofty a claim, as a Poem.

What I here propound is true:—therefore it cannot die:—or if by any means it be now trodden down so that it die, it will "rise again to the Life Everlasting."

Nevertheless it is as a Poem only that I wish this work to be judged after I am dead.

While the cover page of *Eureka*, published in 1848, was strikingly plain, the material inside was anything but simple. Poe considered this "prose poem" his greatest work, though it was difficult to comprehend then and now. Poe is credited for first putting forth the Big Bang Theory long before anyone in the scientific world in this, his longest work of nonfiction.

When examining Poe's entire body of work, *Eureka* stands alone. While Poe was certainly underappreciated in life, now, years after the 200th anniversary of his birth, it may be time to recognize that he has also been undervalued in death. True, he has been heralded by some as America's greatest storyteller and credited with the invention of the detective story, but in fact, his reputation as a master of horror and the macabre may well have been doing him an injustice. While the many Vincent Price movies and Hammer films of the twentieth century brought his plots into the popular consciousness, bobble head dolls and kitschy souvenirs have sometimes transformed a truly great thinker into a comic figure that he was never meant to be.

The Untold Story of the Raven in the Cockade City

From Poe's honeymoon suite, the raven keeps watch over the Siege Museum, the elegant Greek Revival building across the street. Edgar and Virginia would have viewed the alley that still exists and a large warehouse used for religious services. The museum building, erected in 1841, proved to be a white elephant for Petersburg. Initially designed for merchants to display agricultural products, the structure went through many tenants, including the local police, before becoming a museum.

Rene Van Slooten, a Dutch translator of Poe's work and a member of the International Poe Studies Association (PSA), has pointed out that Poe is looked at differently in Europe than he is in his native country. Here, his horrific and grotesque stories are given attention, while in Europe there has always been much interest in his philosophical and scientific work.

"As a 'philosopher of nature' Poe was in complete disagreement with the scientific views of his day that were based on the celestial laws and mechanics of Newton, the so-called 'clockwork universe,'" Van Slooten writes. "In such a mathematically determined and 'closed' universe, there is no room for human freedom and responsibility, because we are no more than cogs in the universal machine that runs on time and gravity."

Harry Lee Poe states that in *Eureka*, Poe proposed what science now calls the Big Bang Theory. "Poe argues that the universe came from one 'primordial particle' that God willed into being," Harry Poe writes. "He anticipated Einstein by arguing that '*Space and Duration* [time] *are one*,' and stresses that with light, 'there is a *continuous* outpouring of *ray-streams*, and *with a force which we have at least no right to suppose varies at all.*'"

"Poe's nineteenth century audience would have thought him crazy for postulating a finite universe that began from a primordial particle," Harry Poe adds.

Themes of dreams within dreams and the very nature of what is real and what is illusion saturate Poe's works and quotations. But his latent work carries these concepts well beyond philosophical meandering to the point of extreme insight in language that is, to the average reader, incomprehensive. Certainly, many thought *Eureka* was the work of someone who had finally gone over the edge. But if it was, in fact, born as much out of changing brain chemistry as of Poe's inherent genius, the brain tumor theory will at least be worth examining in greater depth than is possible here.

Poe wrote, "All that we see or seem is but a dream within a dream." For him, that statement may have transcended poetry to become the true nature of his personal reality.

BIBLIOGRAPHY

Allen, Hervey. *Israfel: The Life and Times of Edgar Allan Poe.* New York: Farrar and Rinehart, 1926.

Bailey, James H. *Old Petersburg.* Richmond: Hale Publishing, 1976.

Barnes, L. Diane. *Artisan Workers in the Upper South; Petersburg Virginia 1920–1865.* Baton Rouge: Louisiana State University Press, 2008.

Carter, Edward C., II, ed. *The Virginia Journals of Benjamin Henry Latrobe, 1795–1798.* New Haven, CT: Yale University Press, 1977.

Copeland, Catherine. *Bravest Surrender: A Petersburg Patchwork.* Richmond: Whittet & Shepperson, 1961.

Haines, Hiram. *Mountain Buds and Blossoms: Wove in a Rustic Garland.* Petersburg, VA: Yancey & Burton, 1825.

Harrison, M. Clifford. *Home to the Cockade City: The Partial Biography of a Southern Town.* Richmond: House of Dietz, 1942.

Hart, Lenore. *The Raven's Bride.* New York: St. Martin's Griffin, 2011.

Lebsock, Suzanne. *The Free Women of Petersburg: Status and Culture in a Southern Town, 1784–1860.* New York: W.W. Norton, 1984.

Northington, Oscar F., Jr. "The Taverns of Old Virginia." *William and Mary College Quarterly Historical Magazine* (n.d.).

O'Neal, Cothburn. *The Very Young Mrs. Poe.* New York: Crown Publishers, 1956.

Poe, Harry Lee. *Edgar Allan Poe: An Illustrated Companion to His Tell-Tale Stories.* New York: Metro Books, 2008.

Scott, James G., and Edward A. Wyatt IV. *Petersburg's Story: A History.* Petersburg, VA: Titmus Optical Company, 1960.

Seagrave, Ronald Roy. *The Early Artisans & Mechanics of Petersburg, Virginia, 1607–1860.* Denver: Outskirts Press, 2010.

Smith, Geddeth, *The Brief Career of Eliza Poe.* London: Associated University Presses, 1988.

Willoughby, Laura E. *Petersburg Then and Now.* Charleston, SC: Arcadia Publishing, 2010.

Wyatt, Edward A., IV. "Virginia Imprint Series Number 9, Preliminary Checklist for Petersburg, 1786–1876." Richmond, Virginia State Library, 1949.